THE INTERNET

UNIVERSE

First published in the United States of
America in 2001 by Universe Publishing
A Division of Rizzoli International
Publications, Inc.
300 Park Avenue South
New York, NY 10010

Distributed to the U.S. trade by
St. Martin's Press, New York

ISBN 0-7893-0636-0

Printed in Hong Kong

This book was created by Laurence King
Publishing Ltd in association with
Creative Review.

Copyright © 2001 Laurence King
Publishing Ltd

Research and Text:
Patrick Burgoyne – patrickb@centaur.co.uk
and Liz Faber – lizfab@EC1Media.co.uk

Research and Design:
Non-objective, Jen Dugan and Tom Hobbs
info@non-objective.com

2001 2002 2003 2004 2005 / 10 9 8 7 6 5 4 3 2 1

DESIGN PROJECT

→USER

Methodology: What are the most important criteria in creating a 'good' website? Usability? A compelling experience? Beauty? In compiling this book we have sought to discover those elements that combine to make a great online product. We asked over 100 leading figures in the creative industries to list their favourite websites or other digital media for carrying out various activities online. We also asked our contributors to detail what it was about their choices that made them appealing, and where they felt they were lacking. The results were distilled to provide a cross-section of design approaches ranging from some of the best-known brands in the world to the downright obscure. Further comment was then invited from our pool of contributors on selected sites to provide a deeper level of criticism and review in our search for the key to 'good design' online. We hope we have provided some answers, or at least some questions that may lead to those answers. **The Authors**

CONTENTS

WHAT IS THE WEB FOR?

It is a question that must have occurred to many of those who have lost their jobs or savings in any of the high-profile dotcom crashes which characterized the grim finale of the first great wave of the web.

As business after business plummeted to earth, commentators began to wonder whether the web wasn't the most overrated new form of communication since CB radio. Just as it had been over-hyped on the way up, the failure of a few high-profile companies was surrounded by equal hysteria.

What we saw was largely a sorting of the wheat of a few viable bus-inesses from the chaff of venture capital sustained schemes that relied on the novelty value of being online for their existence, and that were frequently let down by such old-fashioned problems as distribution and customer service. Some form of rationalization was inevitable: the fact that its victims included companies once valued at millions of dollars says more about the workings of the stock market than it does about the workings of the internet.

We are now in a period of reflection – it is time to catch our breath.

In this series of books, we have tried to explore the outer limits of design for the world wide web in the hope of uncovering likely future directions for its development. Our first effort concentrated on showcasing what was possible. We wanted to convince people that powerful visual communication was possible online at a time when traditional designers were doubtful of the medium's possibilities. Our second volume sought to survey the nascent web design community and determine what was wanted and needed to take such practice on to the next level, to fulfil its early promise.

In this, our third volume, we find ourselves at a crossroads. At the risk of sounding somewhat portentous, there is a battle going on for the heart of the web in particular and for all online media in general. It is a battle that questions the very role of the designer in the development of online media.

The internet is the place where computing and graphic design meet. On the one hand, we have a group which looks at digital media as an extension of the computer desktop. Steeped in the principles of graphical user interface design, they view the web and other applications in those terms. People use the web, they argue, in order to obtain information and to carry out certain tasks. Website design should do as much as it can to facilitate this. Anything that gets between the user and his or her goal should be eliminated.

On the other hand, we have a group which believes that the web can convey experiences that the user can come to value as much as information. The web can entertain, inspire or excite just as film or television can, and it can add to those passive experiences new possibilities of play and exploration through user interaction. Many people go online to enjoy the experience as much as to obtain information.

In crude terms, it is a fight between usability and aesthetics.

Leading the advocates of usability is Jakob Nielsen, the Danish-born guru who has become the acknowledged world authority on the subject. Nielsen defines usability as supporting the user's task, i.e. making it easy for people to do what they want to do.[i] He cites five constituent components: ease of learning, efficiency of use, memorability, user errors and 'how pleasant is it?'[ii]

In one of his bi-weekly Alert-Box online columns (which appear on Nielsen's useit.com website and discuss issues of web usability), Nielsen outlines the essential differences between design for print and design for the web.[iii] He argues that a web page is fundamentally a scrolling experience as opposed to the static canvas experience of print design. Though a certain amount of two-dimensional layout is possible, creating 'a pre-planned experience with a fixed spatial relationship between elements' is impossible. More important, he says, are one-dimensional relationships such as what comes first on the page.

He goes on to argue that 'moving around is what the web is all about'. And because navigation is far more complicated than in print, it becomes an essential component of design. He admits that the web will, in time, be able to compete with print in terms of image quality and speed, but he also points out that improved technology will allow for better interactivity on the web, thus exacerbating the differences between the two.

'Web design is impoverished because too many sites strive for the wrong standards of excellence that made sense in the print world but do not make sufficient advances in interactivity', he concludes. 'Anything that is a great print design is likely to be a lousy web design. There are so many differences between the two media that it is necessary to take different design approaches to utilize the strengths of each medium and minimize its weaknesses.'[iv]

Nielsen advocates standardization in web design. If you can't improve a site's usability 100 per cent by deviating from the norm, then don't deviate, he says. The de facto conventions that have grown up in web design, such as using blue for hypertext links, have occurred because they are successful design: they work, people know how to use them, so don't mess with them. We should be looking to refine and reinforce these conventions, not challenge them.

A particular bugbear is the gratuitous use of Flash: 'Although multimedia has its role on the web, current Flash technology tends to discourage usability for three reasons: it makes bad design more likely, it breaks with the web's fundamental interaction style, and it consumes resources that would be better spent enhancing a site's core value. About 99% of the time, the presence of Flash on a website constitutes a usability disease. Although there are rare occurrences of good Flash design (it even adds value on occasion), the use of Flash typically lowers usability. In most cases, we would be better off if these multimedia objects were removed.'[v]

Nielsen contends that there is a direct link between poor usability and the failure of many dotcoms. Just like any other business, customer service is key. If someone arrives at a website and cannot find what they want simply and quickly they are unlikely to visit again. 'In the future, first of all, websites will be designed by my guidelines ... for the simple reason that if they don't, they are dead', he has claimed.[vi]

Will adherence to usability theory lead to the end of web design? Should all sites conform to a set of strict usability-derived conventions to the extent that the role of the designer is made redundant?

As digital media exploded, so did the numbers of design studios and advertising agencies claiming to offer expertise in the area. To an extent, they learnt as they went along. Designers used to working in print argued, not unreasonably, that their skills were perfectly transferable to the new media, that principles of good information design apply whatever the medium. A situation developed where the design and programming of websites were treated as separate skills carried out by separate communities, not unlike the relationship between graphic designer and repro house or printer.

Others maintained that this was a very unhealthy direction. Design and programming, they claimed, were indivisible where the web was concerned. Some, such as Jake Tilson in Browser,[vii] argued that designers must learn how to write code if they want to work on the web. As we detailed in our last book, John Maeda's Aesthetics and Computation Group at MIT attempted to bring the two fields together.[viii] Its stated mission is to foster the growth of what Maeda calls 'humanist technologists – people that are capable of articulating future culture through informed understanding of the technologies they use'.[ix]

Such an approach finds favour with another usability guru, Bruce 'Tog' Tognazzini. 'Many of today's web designers are completely unschooled in even the most fundamental principles of effective interaction design,' he alleges.[x] Design students and 'human factors' students, he says, 'need to cooperate with each other. Design students indeed spend their time designing. Which is why graphic designers really can turn out beautiful graphics. Human factors students spend their time testing. Which is why they are able to prove that A is inferior to B. If you combine the two disciplines, you have exactly what is needed.'

Faced with the hard evidence of the usability community, designers themselves have started to question their role. The American Institute of Graphic Arts has set up Gain, a print and web publication devoted to design and interactive communication that aims to investigate the designer's role in this new world. In his editor's note in Gain's first issue, David R. Brown comments that 'until recently, the outcome [of the design process] was always an object that had been "authored" by designers and engineers, marketers and makers, and intended for purchase and use by people'.[xi]

Interactive technologies and, specifically, the web changed all that, he argues. Design's manifestation here is not an object, thing, product or anything tangible. Therefore, he argues, using a term that identifies designers in this realm with any one end product – such as web designer or internet designer – is limiting and misleading. Rather, we should term this new area 'experience design' – 'that is, rather than think of an artefact as the final result of design's process and practice, why not focus on the experiences that people have while using interactive media?'

This notion rather forgets that designers have always been involved with creating experiences in some respect. Surely a product designer has the user's experience in mind when crafting anything from a simple kitchen utensil to a sports car? And in the choice of paper, binding, font and colour, the graphic designer recognizes that print's tactility provides an experience for the user/reader. In a sense, all designers are experience designers.

However, this is a very uncertain time in the development of the media as a whole. The hegemony of the TV industry looks set to be usurped by broadband. Previously, a client had clear choices: produce a TV ad and, lately, have a website too. These were both concept driven – a neat 30-second slot and something fun online to build brand awareness. This was easy enough to manage and commission – the client had an ad agency and a new media agency, which were often separate. Broadband and iTV will prompt a move away from working with simple concepts and towards narrative and experiences which can be applied across media and delivery systems.

An excellent amplification of the AIGA's stance is provided by Richard Buchanan in an article from the same publication, reprinted here.[xii] Buchanan recognizes the importance of usability but also contends that 'desirability plays an often decisive role in product selection'. Design has a central strategic role in balancing qualities of usefulness, usability and desirability to create a successful product, he argues.

Design has a role, but designers must learn new skills to fulfil it. We must also remember that the appropriate application of those skills varies considerably depending on the nature of the website or other digital communication product concerned. Jakob Nielsen tends to build his arguments around those websites which have a commercial imperative – the Amazons, eBays and Yahoos of this world. But the web is not just about buying things or looking up information. Of course, that's where much of the money is to be made, but what a dull place it would be if all sites were either ecommerce operations, news services or search engines – just as television would be insufferable were it to consist of nothing but commercials, news and shopping channels. Researchers for the Pew Internet and American Life Project (an investigation into internet users and their habits) asked 3,493 American adults how they spent their time online over Christmas 2000.[xiii] Only 24 per cent of those surveyed bought gifts online. Non-commercial activities, such as sending greetings to family or finding tips on ways to celebrate, far outweighed commercial activity. 'While most analysts and commentators anxiously charted the daily ups and downs of the online retail sector during this season,' the researchers concluded, 'the bigger story about the internet during the holidays was a social one.'

This book attempts to explore the many different ways in which we use digital media and the different design approaches that this might lead to. We have asked leading designers, media theorists and other interested parties to recommend sites which they visit regularly in order to carry out the following activities: watching, researching, playing, sharing, chatting, laughing, travelling, buying, listening and managing.

We have also asked our respondents to look at other online devices as we recognize that the PC/web method may not be the most common means of accessing online information for very long. WAP may have failed in its first incarnation but the next generation of devices, combining the best of mobile phone, PDA and PC, are just around the corner and the 10 million or so Japanese signed up to NTT's DoCoMo i-mode service prove that mobile internet services can be popular. We hope that by analysing these successful sites and devices we can discover more about the role that design can and should play in digital communications.

Will our informed sample skew the results towards design-led sites? We certainly hope so. In this series of books it has been our intention to showcase the most innovative examples of digital design. We have included here many of the most popular sites on the web – hardcore usability-driven sites such as Amazon and Google – but in each category we have also attempted to put forward some alternative approaches. We recognize that in these early days of digital communication, ease of use is a very important factor – for some applications it is the only factor – but we believe that there must be better ways of designing digital communications. There is no reason why a piece of design cannot be both practical and beautiful.

Real, paradigm-shifting progress is only achieved in design, as in any field, by those prepared to challenge existing practice and conventions. Progress will not be made by having all websites designed exactly the same way. Of course the establishment of conventions aids usability, just as it does in magazine design, but this need not lead to the negation of design principles or to website design becoming merely a matter of filling in preset templates.

Interactive media has huge scope for play and for exploration. It is not always a satisfying experience to know exactly where you are and where you are going as soon as you reach a website. For some applications, mystery, surprise, even frustration, can all add considerably to a user's enjoyment. We must remember that today's websites have only scratched the surface of the capabilities of interactive media. As convergence occurs and the internet becomes capable of delivering genuinely rich content at acceptable speeds to the majority of the population, those brands that make entertainment their business will demand a totally different design approach to today's scrolling, text-dominated websites. The factors necessary to ensure repeat visits, customer satisfaction and, increasingly, continued customer spending will be very different.

The advent of broadband and wireless technology has given the client a bewildering choice of 'channels' to reach their public, each with its own particular strengths and limitations. Now convergence is actually happening, developers are faced with a huge learning curve. Clients will no longer see value in buying a $3 million 30-second commercial, especially as devices such as the TIVO allow viewers to edit out the ads! TV channels will see the revenue they traditionally generated from advertisers disappearing into a myriad of different channels. Broadband is going to change the way that television is commissioned – in the UK, Channel 4 has announced that it will not consider TV show proposals in future unless they have an interactive application as well.

iTV is proving to be a very successful shop front in the UK. The fourth biggest Woolworths store now resides on iTV, and Domino's Pizza has derived £1.5 million in orders from its iTV channel. Perhaps every big brand will have an iTV channel as well as a dotcom? Is ecommerce best placed on TV, while anarchic entertainment remains on the web? Will such a development make usability theory redundant?

Preparations must be made for the day when the internet is a very different place to today's web. In order to do that, we believe that we need to explore the limits of today's web, as it is from these innovators that future conventions may be born.

What we do not want to see is innovation restricted to sites created by designers for designers. In an essay written specially for this book (see page 138), Geert Lovink warns against this trend towards 'cosy uselessness'. We may have included some of those sites in this book but this should not necessarily be taken to indicate our wholesale approval of them. Rather, we hope that readers of this book will take successful elements of design from wherever they find it and attempt to apply them in the most appropriate manner. We want to drag innovation out of the design ghetto and into the mainstream.

i 'When Nielsen Speaks' by Yvonne L. Lee, www.webtechniques.com/archives/2001/02/lee

ii ibid.

iii www.useit.com/alertbox/990124.html

iv ibid.

v www.useit.com/alertbox/20001029.html

vi 'Web Guru: It's the User, Stupid' by Peter Catapano, Wired News, 15/11/00, www.wired.com/news/business/0,1367,40155,00.html

vii Browser by Patrick Burgoyne & Liz Faber, Laurence King Publishing/The Internet Design Project, Universe Publishing, 1997

viii Reload: Browser 2.0 by Patrick Burgoyne & Liz Faber, Laurence King Publishing/The Internet Design Project Reloaded, Universe Publishing, 1999

ix acg.media.mit.edu/people/maeda/

x 'The Sorry State of Web Design', www.asktog.com/columns/015WebDesignRant.html

xi Gain, AIGA Journal of Design for the Network Economy, Volume 1, Number 1, AIGA, 2000

xii ibid., 'Good Design in the Digital Age' by Richard Buchanan

xiii 'More People Went Online to Talk and Send Greetings Than Shop' by John Schwartz, New York Times, January 8, 2001

014

essays Jakob Nielsen Richard Buchanan
END OF GOOD DESIGN IN
WEB DESIGN THE DIGITAL AGE

END OF WEB DESIGN

Websites must *tone down their individual appearance and distinct design* in all ways:

- **visual design**

- **terminology and labelling**

- **interaction design and workflow**

- **information architecture**

These changes are driven by four different trends that all lead to the same conclusion:

GOOD DESIGN IN THE DIGITAL AGE

'Good design' is an important issue in current discussions of websites and digital products in general. The explosive development of the digital medium has flooded the market with a wide array of information products of varying quality. Many of these products are highly effective, but a significant number fail to meet the expectations of consumers or satisfy the needs of business. As competition increases, we wonder if there are criteria to guide the development of new products

1 ▪ Jakob's Law of the Internet User Experience

Users spend most of their time on other sites. This means that users prefer your site to work the same way as all the other sites they already know.

This Law is not even a future trend since it has been ruling the web for several years. It has long been true that websites do more business the more standardized their design is.

Think Yahoo and Amazon.

Think 'shopping cart' and the silly little icon.

Think blue text links.

2 ▪ Mobile Internet

Mobility drives small screens (because they are the only ones that can be easily carried) that will often be grayscale (to save battery). Mobile bandwidth will be much more restricted than wired bandwidth. Even though *I don't believe in the current generation of WAP phones*, I am convinced that mobile internet will be big once we get better devices – but even

these next-generation mobiles will have much smaller screens than PCs. This drives a focus on content and solutions: don't spend screen space on navigation features except for the most necessary ones. With less space for navigation, it becomes more important to stick to standard conventions for where to go and how to explain the options.

for the digital environment. Is there a practical framework we can use as a touchstone in judging the quality of new products?

Perhaps the greatest change in good design today, comes from a change in the designer's stance. By this, I mean the designer's perspective on the problem of designing effective products for the marketplace. Much of design thinking throughout the 20th century gave us an external perspective on products.

The focus was on form, function, materials and the manner of industrial production. While the close connection of form and function pointed to the value of product performance, the product itself was judged in isolation from the immediate situation of use.

This is where good design today departs significantly from the past. Designers place a premium on performance, but the designer's stance is more intimately involved with human experience. Designers today explore products from the inside, focusing attention on performance as it is understood by the people

who use products. For this reason, many designers explore 'user experience' and employ insights from the social and behavioural sciences. They explore not only form and function, but also form and content, since content is what human beings seek in digital experiences. In short, designers explore what is useful, usable and desirable in products.

3 ▪ Network Computing

4 ▪ Syndicated Content and Services

The network is the user experience that will integrate use of computers and information appliances across locations and devices to form a seamless whole. How can it be seamless if the rules change every time you use a different device? If mobile internet needs to become simplified, so does wired internet.

When you deliver a service over multiple devices, users should be able to recognize that it is the same service. Many of the same features should be delivered on each platform, even though some features may be elided or pushed into the background on devices where they make less sense or are harder to deliver with decent usability. These considerations force emphasis on the semantics and not on the representation.

The days of the unified website are long gone. From about 1993 to 1998, most websites were like Roman military camps: everything inside the barricades was carefully planned and constructed by the residents of the camp. The (fire)wall marked the end of control: everything outside was wilderness and not connected with the site.

This is in contrast to the early years of the Web in 1991 and 1992, where the content on any given server was not connected with anything else on that server to any greater extent than it was connected to the rest of the web. The web was a unity and there was no special treatment of pages that belonged to a single site.

Many people believe that the only task of design is to provide styling to the visual appearance of products. This is a mistaken conception, comparable to the idea of the man in the street that the primary job of a CEO is to put a public face on the workings of his or her corporation. While visual expression is an important part of the work of the designer, the fundamental work lies in discovering the central argument of a product: the dramatic plot that shapes human interaction. What I mean by 'argument' or 'plot' is the ability of a product to fully engage a human being in support of a particular activity – whether the activity is a search for information, the conduct of a

transaction or the casual enjoyment of exploring how other people express themselves in the new medium. Design is not a trivial aspect of the development of information technologies; it is the central discipline for humanizing all technologies, turning them to human purpose and enjoyment. In creating interactive digital environments, the designer's stance is grounded in effective communication. This means more than simply conveying information or doing so in a manner that is persuasive in the narrow sense of seducing and manipulating. It means engaging the intended community of end-users in a lively process of perception, judgement

and action. Here is where the criteria of good design enter – and here is where I will give a personal interpretation of what I see emerging around us in digital products.

When I first encounter a website or other digital product, I ask, What is its intended use? What is it useful for in my life? In short, I look for content and purpose, and I make a fateful commitment to trust those who have conceived and designed the product. What I trust is that designers have tamed the complexity of the content, shaping it with intellectual efficiency and clarity. This is what it means to create a useful product,

one that does its job well. In fact, the first task of the designer is to understand the content of the product, and to this end designers often collaborate with those who are expert in the content. What the designer adds, however, is a significant measure of common sense – sometimes lacking in content experts who know their subject matter but do not know how to present its logic to an ordinary human being.

Since approximately 1998, it has become more common for websites to rely on syndicated content that flows both in and out of the site. When writing content that can appear on multiple websites, it becomes necessary to restrict the content design to a few mechanisms that will work everywhere, such as headlines, bulleted lists, and highlighted keywords.

Similarly, when a website imports many of its features and content, it typically becomes necessary to conserve resources and expend as little effort as possible on massaging the imports to fit within the site. As long as everything is about the same, it works. Anything too special and you have a conflict.

Application service providers also make it harder for websites to retain overly distinctive design. It is getting to be common for some of the features of a website to reside on *other sites* that supply certain specialized functionality such as mailing lists, search, conference registration, shopping carts, promotions or

coupons, and much more. As users engage outsourced functionality, they would ideally not notice that they have been temporarily moved to a different site for the duration of a certain feature. The feeling should be that of *remaining within a single smooth interaction.*

Currently, ASPs offer limited means of editing their pages to approximate the appearance of the client site, but it is usually difficult to make outsourced pages feel identical to locally hosted pages unless both have very simple designs.

Expert User Support Requires Sites to Relinquish Control

In the last five years, the web has forced a severe focus on novice users. Basically, all web users are novices all the time, since you very rarely use any individual website long enough to become an expert user.

Even when some users return often enough to become skilled users, the site still needs to target novices in its design since people will not enter a website if it is not immediately obvious how to use it in a few seconds. *Zero learning time or die.*

I can seldom judge the full logic of a digital product on first encounter, and that is why trust is important in the beginning. Logic, structure and 'rules of engagement' emerge only slowly, over time. But this is where the second question comes forward in my mind: Do I have easy access to the product? Is it usable from the first screen, the first cursor blink? Can I begin a personal exploration without fear of making fatal mistakes? I do not ask for precise

instructions, because I, like many others, like to play with the environment in my own personal way. But I do ask for important navigational clues – and they are particularly important when the product should serve an intensely practical purpose, such as financial transaction. In fact, this is the second task of the designer: to understand my needs and limitations, and to provide the 'affordances' that enable me to move forward with a feeling of

accomplishment and satisfaction. Admittedly, this is a very difficult matter, requiring not only common sense but a specialist's knowledge of the mind and body. For this reason, designers work closely with 'usability' specialists, who are often cognitive psychologists and social scientists – experts who have studied things like the limits of short-term memory in human beings, the most comfortable patterns of information

display or the willingness of an ordinary person to cope with ambiguity and uncertainty. Here, too, the designer adds something important that technical experts may neglect – the ability to bring grace and elegance into forms and devices that are humanly engaging, often exciting and sometimes unexpected. Designers add marvel, and that can make a product more deeply usable, reaching beyond the prosaic or pedestrian.

What Remains
in Web Design

The way to resolve the tension between experienced users' needs for advanced features and first-time visitors' need for extreme simplicity is to move the expert features into the browser or other client software. Two simple examples: the 'Back' button and bookmarks. Both work well because they have been removed from the domain of the site and thus work the same everywhere (except for those sites that cluelessly break the standards).

If an expert feature is either standardized across all sites or supported by the client software then it will be available to experienced users without having to be visually apparent in the site design. Thus, it will not cause learning difficulties for novice users. On the contrary, a *first-time visitor to a site will be able to use expert features* without having to learn the site because he or she can transfer learning from other sites.

Even as websites become more similar and appearance design becomes more simplified, there will be a large number of design decisions that still need to be made in order to optimize the usability of each individual site.

Most important, each internet service needs to be based on a *task analysis* of its specific users and their needs. You can combine standardized user interface elements in *many* ways, and the better sites will support the way *users* want to approach the problems.

For example, even if you always call search 'Search' and you always have the same way of distinguishing between simple search and advanced search, the question will remain whether advanced search makes sense for any specific site.

Usability counts for a lot in any encounter with a new product. It is what allows me to explore the product and discover what it has to offer. But there is a third question that enters my mind soon after the first and second questions: Do I really want to explore this product? This is a very personal question. It goes beyond the utility of the product and beyond issues of usability. When I have choices in the market-place, why should I select this product over that? Why do I feel more comfortable with a particular website or other digital convenience? This is the subtle domain of the desirable, and it is often neglected – particularly when the culture of a company

focuses on engineering and computer programming or when there are few choices available among competitors. But desirability plays an important and often decisive role in product selection. Does the product speak to me in a 'voice' that makes me comfortable and that, just by its tone and quality, builds a bridge of identification and trust with me?

At first glance, this is an issue for marketing experts, since they study the deep appeal of products across different segments of the marketplace. For this reason, designers often work closely with marketing experts to develop strong and consistent branding strategies. Whereas marketing tends to stop at the segment level of analysis – addressing the general qualities that appeal to a general group of consumers –

designers transform such assessments into concrete product features. By the nature of their own expertise, designers often explore unexpected or not easily predicted features that add distinction to the voice of a product. Sometimes these are aesthetic qualities, but often the features added by the designer are best regarded simply as cultural expressions suited to the pluralism of contemporary life.

Content design will also remain. Each product description is different. Each opinion piece is different. There will always be a need to determine the best approach to describing each unit of information.

Information architecture will partly become standardized. An example that has already happened is the *'About the company'* area of most corporate websites. All users expect this area to contain subsites about the management, the company history, financial information and investor information, PR and press

releases, and employment opportunities. But the way these subsites are structured might differ depending on the characteristics of the specific company. Similarly, there would be many other areas that were related to individual products or services and that would be structured differently on different sites.

Jakob Nielsen *is a User Advocate and principal of the Nielsen Norman Group which he co-founded with Dr Donald A. Norman (former VP of research at Apple Computer). Until 1998 he was a Sun Microsystems Distinguished Engineer. This article has been reprinted from http://www.useit.com/alertbox/20000723.html*

Qualities of usefulness, usability and desirability play a central role in good design for websites and all digital products. But there is one final step to turn them into useful tools of product development: discovering the proper balance of all three qualities for a particular product and the people who use the product. This is a strategic design decision, because it is fundamental in developing any product. If these are the criteria for good design in the digital environment, it is evident that they do not set a simple standard for quantitatively measuring the value of every product. In fact, the criteria help to explain the incredible diversity of good products

today and the diversity of designers, since the range of utility, usability and desirability is so great. More important, the criteria suggested here should help guide strategic design planning as managers seek special niche opportunities

and product differentiation in the marketplace. The real challenge in seeking good design is to distinguish in every individual case how the elements of the useful, usable and desirable are poorly or successfully explored for effective communication.

Richard Buchanan *is head of the School of Design at Carnegie Mellon University, Pittsburgh, PA. His work addresses issues of verbal and visual communication, communication planning and design, and interaction design. He is editor of the international journal* Design Issues *and co-editor of* Discovering Design: Explorations in Design Studies *and* The Idea of Design. *Reprinted by permission of Gain: AIGA Journal of Design for the Network Economy,* November 2000, *where this article first appeared.*

WATCH

We may all still be waiting for broadband but there is entertaining viewing available on the web already, even if it takes a while to download and nearly always seems to involve some new plug-in. Sites such as www.atomfilms.com have provided much-needed exposure for short films and new models of revenue generation. However, sites can be victims of their own success as heavy traffic can result in heavy bills from hosting companies – as Al Sacui of www.nosepilot.com knows only too well.

HEAVY

Overloaded with content, Heavy is a hint of what we can expect
from broadband websites. With large photographic images,
animations and videos, the site is confusing to navigate –
incomprehensible but great fun nevertheless. Heavy's irreverent
content and tone brings it closer to a public access channel
than a website.

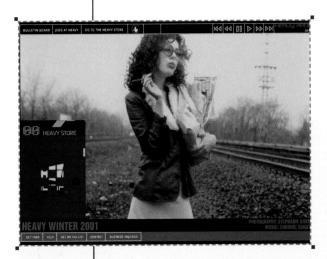

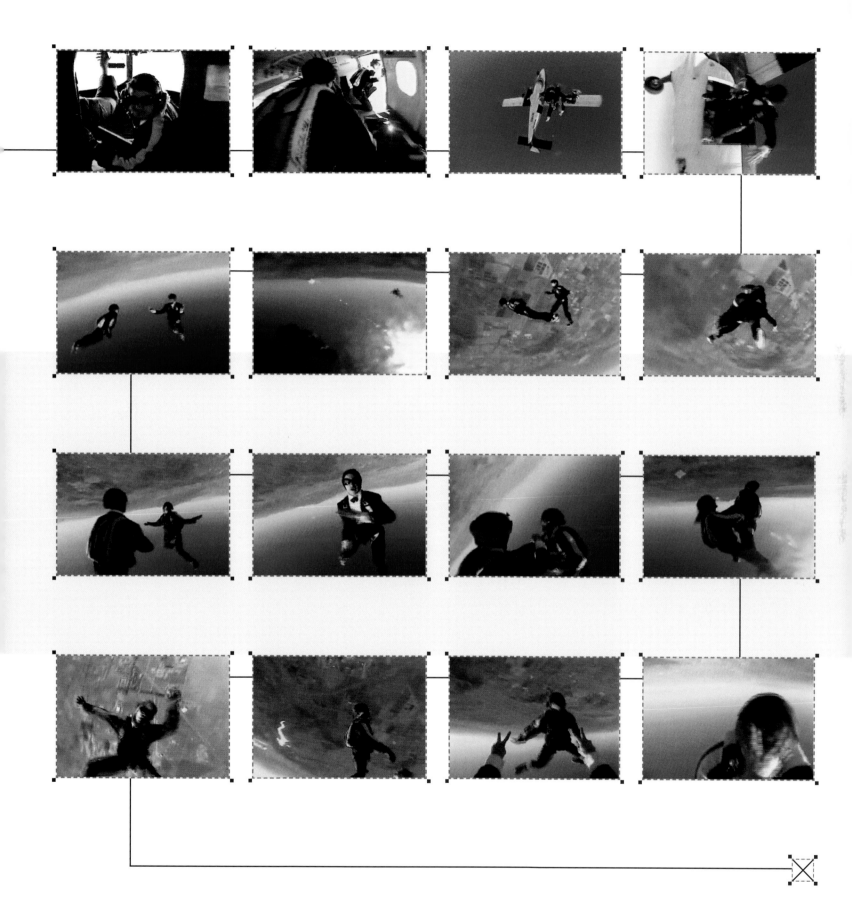

WWW.ATOMFILMS.COM ATOM FILMS ENTERTAINMENT FLASH, QUICKTIME, REAL PLAYER

ATOM FILMS

Leading short films company Atom Films credit themselves with inventing a new industry. While short film aggregation has always existed in TV and cinema, it certainly hasn't happened on such a major scale. Due to the 'snack' nature of web viewing, programming needs to be kept fast – Atom found its niche at the right moment. In a short time it has built up a large range of great content, and owns over 1,000 exclusive videos. Atom syndicates content to businesses all over the world. The market looks set to explode with the advent of broadband wireless.

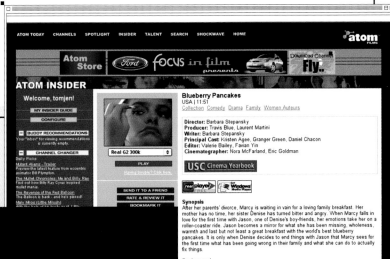

Mike Maxwell
Digital Arts

A site where content rules, so graphic and interaction design are not a primary consideration. This site shows up the issue of how sponsorship branding is used, as it really does affect the overall experience (is this an Atom Films or a ShopSmart.com production?). Retail designers use a similar technique when they rack suggested purchases together, encouraging the consumer to buy additional items. You want to buy a pizza? How about some crisps as well, you couch potato?

Atom seems to have gone for wholesale adoption of this school of thinking. For the novice or those unfamiliar with 'web vernacular', things get tough from the outset. The 'zoo-like' nature of the interface could prove too daunting to proceed. However, the site does boast a host of awards. The recommendation I would make is perhaps a reconsideration of consistency of concept, interaction, brand identity and message to ease the outsider to insider status.

BANJA

Banja bills itself as both an individual and a community game.
Set on the island of Itland, users play a Rasta character
called Banja. Their challenge is to strike up personal relation-
ships with other characters they meet on their travels around
the island. Like a TV show the game is played in episodes and
the island evolves in real time as the story unfolds. The true
objective is to get really involved in the community, for example,
it took the actions of 1000 players to restore power to the
island after a blackout. Banja also contains some of the most
innovative chat rooms on the net.

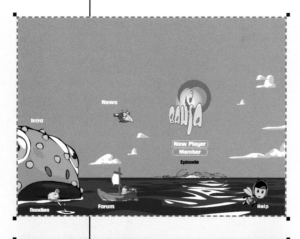

CENTER OF THE WORLD

The movie business has been quick to harness the power of the net as a marketing tool. Artisan Entertainment changed the way that movies were marketed with The Blair Witch Project. To promote The Center of the World, a movie about a tec wizard and a stripper, they asked Hi-Res! to create a suitably sleazy online strip club. Users navigate their way around a lap-dancing club by clicking on vectors of the strippers. The site successfully conveys the one-on-one experience of a lap-dance. Two further sections add depth to the project: mocked-up webcams in the girls' changing rooms and a chat zone where you can talk to a girl.

2: 3/14/01 5:13pm

2,000 MB
232,055.08 MB

NOSEPILOT

The irony of the web is that the more successful your site is, the more you have to pay for the hosting. This principle is fine for big businesses, but not so great for the enthusiast. Al Sacui, the founder and creator of Nosepilot, discovered to his horror that he owed his hosting company over $16,000. All he had done was to put up a 5MB animation which explored, among other things, a woman's relationship with a slug and an Evil Exploding Robotic Duck.

1 2 3 4 cat

thursday 3/8/01 4:04 pm
about 1 hour ago i received a phone call from a lawyer at gisol.com all of a sudden i owe my server provider over $16,000.
i had no idea the traffic to my site had exploded... so much. they're trying to tell me that the called me when my traffic exploded... i never talked to them... its of no consequence, really.
i am legally... screwed.
(ive had nosepilot with this server for 4 or so months. ive paid everything in advance. and this new development has... blown me away. i have mad $100 off nosepilot. i have a couple thousand to my name. i.. am. dead.
if you can help.... please do
al sacui
1330 pine st b102
philadelphia
pa 19107
usa
please

3/8/01
8:23PM
right
so heres some background info. the traffic stats look something like this:

Tue Feb 6 2001:		3091
Wed Feb 7 2001:		2918
Thu Feb 8 2001:		2857
Fri Feb 9 2001:		2698
Sat Feb 10 2001:		2396
Sun Feb 11 2001:		2212
Mon Feb 12 2001:		1931
Tue Feb 13 2001:		1934
Wed Feb 14 2001:		3290
Thu Feb 15 2001:		4038
Fri Feb 16 2001:		4359
Sat Feb 17 2001:		9909
Sun Feb 18 2001:		4857
Mon Feb 19 2001:		4954
Tue Feb 20 2001:		4072
Wed Feb 21 2001:		3722
Thu Feb 22 2001:		3593
Fri Feb 23 2001:		4720
Sat Feb 24 2001:		3560
Sun Feb 25 2001:		2947
Mon Feb 26 2001:		3457
Tue Feb 27 2001:		2894
Wed Feb 28 2001:		3078
Thu Mar 1 2001:		3298
Fri Mar 2 2001:		3298
Sat Mar 3 2001:		2515
Sun Mar 4 2001:		2494
Mon Mar 5 2001:		2848
Tue Mar 6 2001:		3089
Wed Mar 7 2001:		3063
Total:		104092

RESEARCH

The web is the greatest research tool we have. Whether searching for a photograph to use in an advertising campaign (as at web.altavista.com/cgi-bin/query?pg=q&s type=simage) or the perfect song to fit a mood (www.moodlogic.com), keeping an eye on the output of peers (www.k10k.com) or learning a new design technique (www.noodlebox.com/bitsandpieces or www.typographic56.co.uk) the web brings it all to the desktop. The sheer quantity of information can be overwhelming, however: what is needed is greater quality, the intervention of electronic librarians to guide us. To this end, a huge amount of work is being done on refining search engines and creating intelligent agents. This is just a small selection of the research facilities out there, using our best of breed criteria to pull out the creative community's favourites.

034 RESEARCH

design	function	technology	
WWW.GOOGLE.COM	GOOGLE, INC.	SEARCH ENGINE	HTML, JAVASCRIPT

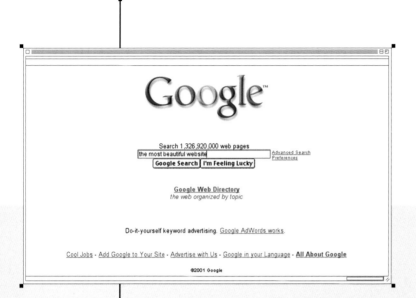

GOOGLE

Of all the internet's search engines, Google is the purest. Its lack of extraneous content enables users to concentrate firmly on the task in hand. No banners, no superfluous content, just text on a white background and results, lots of them.

Jonathan Wells
ResFest

Google is fast, accurate and simple. It follows the dictum KISS – keep it simple, stupid. It is fast, unlike most websites. It's not cluttered with banner ads, the homepage makes ample use of white space, a novelty in web design. It is very accurate, I can quickly find what I'm looking for and be on my merry way. I use this site every day for just about anything for about one to five minutes each time. I use it primarily at work, but sometimes at home too.

Liz Malia
Cube Consultants

I get what I want every time I visit it. It is idiot proof, you can't not use it properly. It responds immediately and it has no advertising – just the site. It never fails to produce the goods, even when I ask it something unusual. I use it every day for around two minutes each time. The best thing about it is its ability to record information in a logical manner with the highest match first. What is the most useless thing about this site? Nothing!

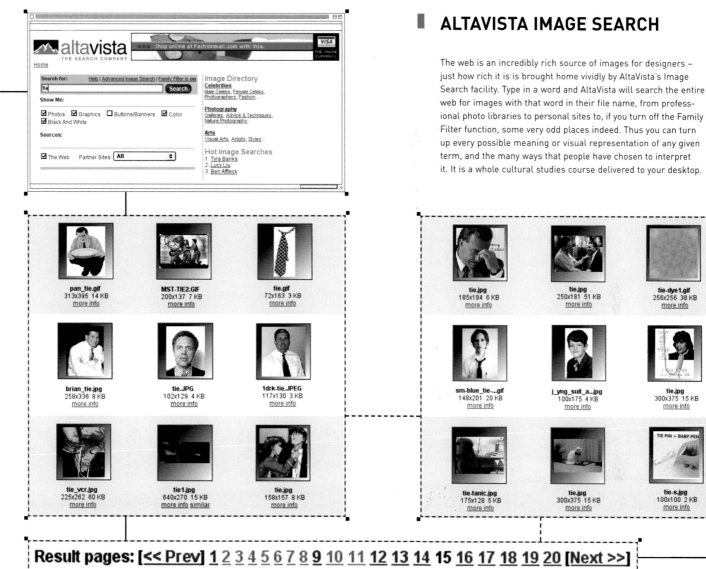

ALTAVISTA IMAGE SEARCH

The web is an incredibly rich source of images for designers – just how rich it is is brought home vividly by AltaVista's Image Search facility. Type in a word and AltaVista will search the entire web for images with that word in their file name, from professional photo libraries to personal sites to, if you turn off the Family Filter function, some very odd places indeed. Thus you can turn up every possible meaning or visual representation of any given term, and the many ways that people have chosen to interpret it. It is a whole cultural studies course delivered to your desktop.

Steve Bowden
The Chopping Block

This site is brilliant, but often very distracting. Primarily it's a fantastic tool when you need source imagery for an illustration or a placement image for something that only requires a small, low-res image. I use it frequently when I'm in need of several pictures of an object to compare in order to composite something. It sometimes takes a little while, but it's out there somewhere.

It's amazing what one finds surfing the web via people's naming conventions. If you look up a fairly vague word like 'tie', for instance, you'll get family photos of people tying each other up, a tie-shaped navbar of some comedy team, some wrestlers, an electrical generator, a couple of tie fighters and several pictures of ties. One of them even has 'kkk' in bold letters down its centre, another holds keys. Only two of the first 12 thumbnails actually show normal ties. Often I'll gravitate more towards the wrestlers.

Design-wise there is little to be said: it's just another nasty looking portal. As far as information architecture, it works, and I'm sure all these embellishments around the search field do someone some good.

design	function	technology
MSCHMIDT, TOKEN, PER	DESIGN PORTAL	CUSTOM BUILT ASP BACK-END, DHTML, JAVASCRIPT, HTML

WWW.K10K.COM

on display

we proudly present issue #104

Matt Owens
One9ine

k10k is like the CNN of web de-
sign, I can always get the latest
info there. It is simple, contains
a lot of great information and
is frequently updated. It keeps
me informed about the design
community which I feel strongly
invested in. I use it to post in-
formation and read information
and find out about the latest
new work online. I use it at least
once a day.

Matthew Richmond
The Chopping Block

It's a gathering place of fresh
work, created by talented indiv-
iduals with similar interests.
Some afternoons it impresses
me, other times it pisses me
off, but most of the time it keeps
me thinking. It feeds me.

Visually, it's clean, the 'design'
does not get in the way of the

K10K

A design community resource par excellence, k10k enjoys a formidable reputation. Its busy, highly detailed interface conveys a huge amount of content including site reviews, forums, links and competitions.

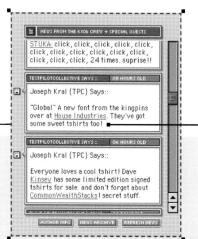

content. It works as a slow, never-ending conversation on what is new and intelligent, without the hi-tech, bloated nature of chat engines and bulletin board systems. Unfortunately it's a closed conversation, but that sometimes adds to its pace. At times, it would be nice to jump in, yet if the floodgates were to be opened, the site would not be as good. It's probably best left

the way it is. It would be nice to hear a bit from those who make beautiful stuff; lots of these sites lately are about hearing from the critics about beautiful stuff. I'm just going to try to make good stuff ... occasionally I will check in on the conversation at k10k.com. It is an interesting jumping-off point when you want to see what is out there (it's the *New York Times* of the know-it-all web

designer world). Marginally elitist, yet driven by genuine desire to make the next great thing. I use it every few days for five to thirty minutes.

K1Ok SPECIAL FEATURES

rants
+
raves

THE K1Ok CREW + BARNEY THE BEAGLE PRESENTS : RANTS+RAVES

A couple of weeks ago mschmidt was kind of pissed off, kind of depressed, kind of bored with it all. He felt the need to rant a bit, to bitch & whine & try to get everything bad out of his system.

He decided to write a long post at K1Ok, complaining about the lack of decent content on today's leading edge design-sites, and the general "form over function"-mentality that seemed to prevail whereever he turned his eyes.

At the time, we had **no idea** how much reponse this posting would provoke and we quickly found ourselves deluged with some of the most interesting emails we've received in years.

So, with the aide of new corporate mascot, Barney the Beagle, we now have the pleasure of presenting **the rants+raves special feature** - an uncensored, unbiased look into the thoughts, ideas & feelings of everyone who responded.

Have fun,
mschmidt + token + per + barney

- Recent rant
- thanks for the rant
- ...but it was nice to hear you say it.
- Your Rant
- wha?!
- depressed
- hey ranting fool
- Thank you
- K1Ok : cameron's comments
- rant
- K1Ok : token's comment 02
- yet more feedback
- content and form
- this 'content' talk
- rant
- rant rant rant rant

TRAINING THE BEAGLE | MS works on stuff | bjork on a TN visit | CELEBRATING PER | MS brushes teeth | TN+Naomi at GE club | TN trains in the gym | TRAINING THE BEAGLE | DA

George Shaw
onetendesign

A big part of my work as a designer is finding out what else is happening in design. For that reason, I spend a lot of time looking at sites that are considered to be good design. Sites that point out well-designed sites are good starting points. For this, I generally start at CommArts, then move on to Macromedia, then on to k10k and other personal design community sites.

Alex Wittholz
Helios

It has a fast load, no splash pages or plug-ins, email-based news submissions. It keeps me abreast of current design trends. I use it several times a day, probably for 10 minutes each time.

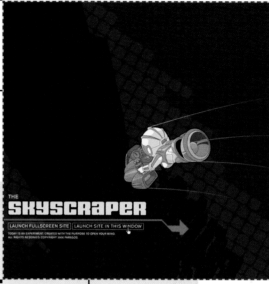

Michael Schmidt
k10k

The k10k site is modular, works well, is extremely browser and platform compatible, relatively fast and always fresh. Every little detail has been worked on, over and over and over again. It does not try to do everything. It is the tiny things that together make a whole, the hidden animations, the smoothness of the mouseovers. It's our little baby, our pet project, the hamster that's outgrown its box and now needs more space to roam freely. We are designers – we think it's the best design resource out there, and completely invaluable if you need an inspirational fix. We use it several times a day, whenever we need a break from whatever we're working on.

Best thing? The news feed – it's always updated, always relevant, always interesting, and from all corners of the globe. Most useless thing about this site? The merchandise section – which should be updated more often. No T-shirts in stock.

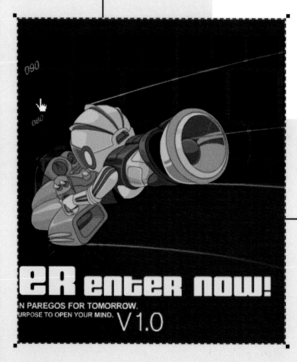

SKYSCRAPER

Life in the Arctic Circle must be pretty intense, so what better way to while away the winter darkness than a spot of Flash programming, which is exactly what Paregos have done. Lots of work has gone into their site, which is as full and detailed as a commercial venture. On the site the Paregos crew interact with people who want to learn about Flash programming via step-by-step instructions on how the site was built.

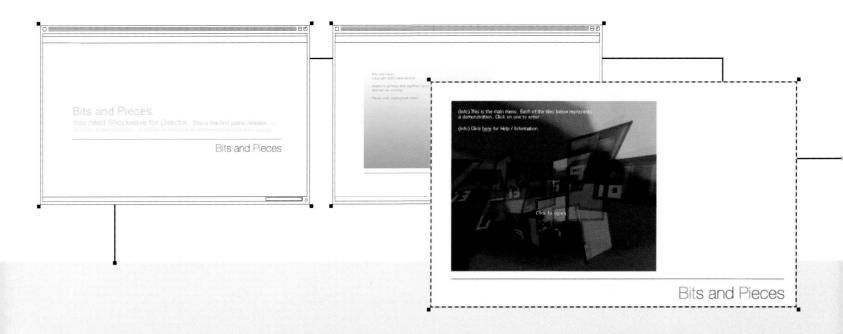

James Tindall
squarerootof-1.com

In the years since Danny Brown's first site, the incredible Mr Noodlebox, was launched, it has been the inspiration of many internet art sites. Most of them, unlike Noodlebox, have been produced in Flash, and most, again unlike Noodlebox, have dated very quickly.

Bits and Pieces takes the Noodlebox brand and updates it for the new millennium. As in Noodlebox, the navigation metaphor is an architectural one, with the main menu structure providing access to the various 'rooms' and 'spaces'. Also familiar are the back icons and the wonderfully smooth transitions between movies.

However, there's plenty here which has never been seen anywhere before.

Not only does Bits and Pieces reach new heights in its technical execution and entirely transparent interface design, but it suggests a more organic aesthetic as an alternative to the ubiquitous ultra-clean digital design. There is also a new-found sense of light and texture which are both enriched by beautiful blurred motion and a sense of real depth; together they provide not only new visual feasts but some genuinely innovative tactile sensations.

My only criticism, although it is not really a criticism, is that I'd like to see more. The one-off Bits and Pieces approach

certainly adds to the novelty of each piece, but I think they would be even stronger if an entire series was dedicated to each one.

From the mesmerizing infinite symmetries of #8 to the breath-taking organic form of #5, Bits and Pieces is undeniably both visually and mathematical-ly beautiful. This is truly contemporary art, a title internet art is rarely worthy of, but unlike much contemporary art and most internet art there is no exclusive language here. Bits and Pieces speaks gently in a language that anyone can understand.

BITS AND PIECES

Danny Brown's Mr Noodlebox is a favourite among the design
community with its beautifully crafted experiments in
interactivity. In this follow up, Brown attempts to elicit emotional
responses from users by creating a series of spaces which each
seek to reveal the links between the digital and the organic.

TRIPLECODE

The Mood Magnet browser is an intriguing take on a new generation
of search engine. It was produced for Mood Logic, a music website
that aims to help users find tracks to match their particular mood
of the moment. With the Magnet browser you can not only search for
tracks by genre, voice type, artist, etc. but you can also search by
mood, e.g. mellow, aggressive, happy. The user picks which moods
they'd like from a list and drags them to the centre. The results of a
search are then clustered around these mood nodes.

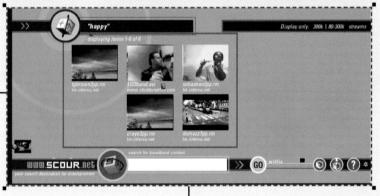

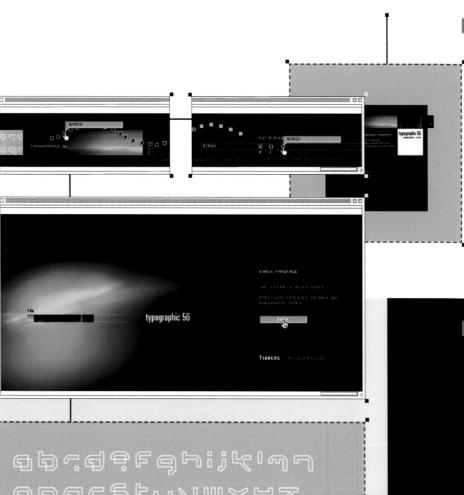

TYPOGRAPHIC 56

The phenomenon of designers sharing new techniques is a unique and admirable facet of the web. This experimental on-screen typography magazine site from the designers at London-based new media studio, Deepend, features a mixture of themed projects/experiments for others to admire and be inspired by. The interface would no doubt drive Jakob Nielsen crazy, but once you've figured it out (not difficult) it's surprisingly pleasant to use, with a menu in the top window and work displayed in a second window below. Drag a square from the curved display to the active area (bottom right) to make your selection.

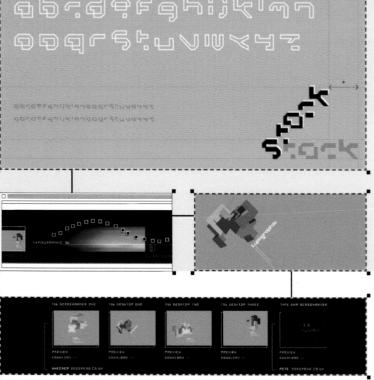

Vassilios Alexiou
Less Rain

Creative people often need space to make things outside their 'work' and Typographic 56 is a good example of this. Making a site that complements a typographic magazine, even for just one issue, can be inspiring for both web and print designers. The quality of work presented here is generally quite high and with adequate theoretical background, although the word 'experiment' is sometimes overused – standing for something of no use or a technical mannerism. The interface is a bit too sophisticated for the functions it provides; the 'eight most recent' choices interface is more confusing than helpful and there really is no 'box' to put pixels in – just a border. However, the site is useful to all web designers who feel the need to revitalize their relationship with interactive typography – especially the ones who forgot about it right after they left college.

PRAYSTATION

PrayStation is an internet design legend. Created by New York-based technologist Joshua Davis, PrayStation really captures the spirit of the internet. The site is a source of inspiration for Flash developers who visit PrayStation to download innovative Flash code made by Davis. They can use his code as long as they credit him on their own sites. Davis also encourages people to modify the files and send them back to him – that way he is able to tell how people furthered his work, and everybody learns. PrayStation reflects the best of web development.

Pete Barr-Watson
Kerb

Praystation is the personal project of Josh Davis who currently works for Kioken in New York City. It is an experimental zone where Josh places the stuff he has been toying with for the Flash community to both see and download. He would be the first person to admit that the site is not well designed, but he's wrong about that. Clear and concise usability is paramount on the site, which takes the form of a working calendar. Days on which Josh has uploaded his work are high-lighted on the calendar and when you click on them you are presented with a 'stage' where the work is described and displayed. Once you have viewed the work you are able to download the source Flash files in order to experiment with them yourself. Sharing knowledge is definitely Josh's thing and he welcomes you to send the modified files back to him so he can, in turn, learn what you did to them. The quality of the work is very high and his experimentation with the concepts behind the work is very interesting too.

He will start with an idea and proceed to make it work on the first day. On day two, he will enhance the concept and make it better. Day three might see him develop the initial idea in a diff-erent way and day four will see him questioning the whole concept in the first place! Open source has never been this good. For a person of Josh's level to be giving his code away is almost unheard of. For the intermediate Flash programmer it is like heaven on earth; not only do you get to see all of this amazing stuff but you get to pull it apart too. Fantastic work.

I understand that Josh is releasing a new CD-ROM later on this year comprising the contents of his hard drive from the last 12 months. You get to see just a fraction of what he has been working on within the site and this is your chance to see the stuff that didn't make it. Everything is there from personal photos to as yet unavailable source code! There won't be any weird or won-derful interface design, you'll just have to browse the CD using standard OS software. Packaged in a box that resembles a Playstation2, I think the CD may suffer from the same kind of distribution problems too – once people know it is available I think it'll sell out before you know it.

PLAY

Much successful multimedia involves an element of play as a means of providing a richer experience for the user – just think how many corporate sites tag on a few lame games in a vain attempt to attract traffic. But when play is put at the heart of the exercise the results can be captivating and even beautiful.

052 PLAY

WWW.NICK.COM

design
NICKELODEON
ONLINE

function
PROMOTIONAL

technology
FLASH,
SHOCKWAVE

NICKELODEON

The games zone on nick.com is absolutely crammed full and divided into categories such as brain games, kids, branded games, sports, multiplayer and, of course, games featuring Nick's own characters including the Angry Beavers and the Rugrats. The games use the latest technologies, such as 3D graphics. More interestingly, Nickelodeon is using the games zone to produce games that synchronize with its TV broadcasts, allowing viewers to play along while watching.

Jake Tilson
The Cooker

The Audio Farm radio station is addictive – farmyard sounds interspersed with the occasional song. Have it on when you look at the site. If like my daughter, Hannah, and I you already spend the early hours of Saturday with Rugrats, Wild Thornberrys, Ahhh Real Monsters, Angry Beavers and the weird CatDog, you'll feel at home here. Like weekend morning TV the site is aimed at the teen market. Lots of what you would expect: games, music, chat, sounds, desktops and TV schedules. Taking it further though are streaming videos of selected shows, online multiplayer games, radio channels and TV-alongside-browser games. I wonder if they synchronize the advertising on web and TV when 'live'? Merchandising is sort of kept at arm's length on another site as it is for younger kids – nickjr.com. Sound is well treated – background music fades out, great rollover sounds in the Rugrats area. The downside – it is unashamedly USA-centric, mirror sites that cut out US TV schedules wouldn't be too hard. Don't visit with Netscape 6, try Netscape 5 (Mac) or Internet Explorer 5 (PC). Come well armed with plug-ins.

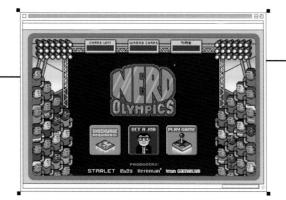

NERD OLYMPICS

eBoy's distinctive graphic icons give credibility to the Nerd Olympics, a Shockwave game for those bearded ones. The site allows coders to pit their skills against the clock and rank themselves on league tables. Select your favourite code, from HTML, Basic, ASP to Lingo, and get writing. Most of the leaders on the board were Scandinavian.

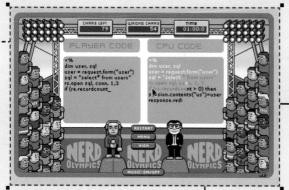

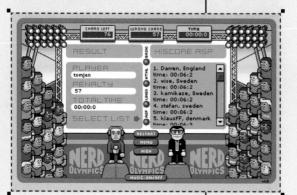

Vassilios Alexiou
Less Rain

It's a brilliant idea, simple and effective. Not so exciting to play, unless of course you are a nerd! Their trademark pixelated characters are superb but really, it is the idea that counts. It turns out that they received mail from real hardcore nerds complaining that Cobol and Fortran should have been an option!

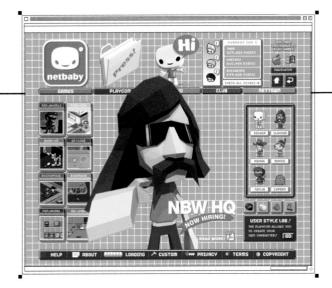

Alex Wittholz
Helios

I like Netbabyworld for several reasons. It has incredibly tight graphics combined with really well done (and fairly complex) Director programming. The playability of these games borders on addictive. The small format is disarming; at first glance you don't realize how much work went into these games. The art direction puts a unique spin on the currently hot pixelpeople style of illustration. There is definitely a Netbaby look. My favorite part of this site is that somebody spent an unbelievable amount of time on it without any obvious or blatant attempt to somehow make the site pay for itself. These people should be well positioned to become multimillionairemegasuperstars once a service like DoCoMo's i-mode phones in Japan takes off in Europe and North America. The potential for these games to be played in a multi-user environment, in the subway, on your way to work, makes me want to run naked through the frozen tundra. (This is a good thing.)

NETBABYWORLD

Net Baby World is a free online games community; its goal is to become 'the most entertaining online experience' on the net. The games are detailed, cutesy and much better than average. Unlike console games Net Baby products contain no sex or violence.

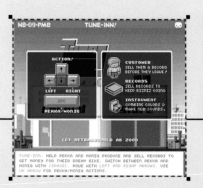

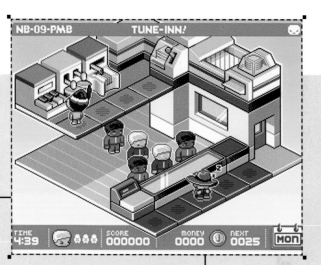

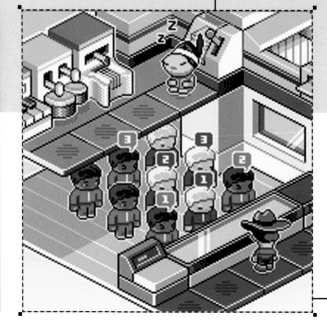

Michael Schmidt
k10k

It's cute, it's sexy, it's Swedish, and they have their very own, unique style. We gasp at the amount of detail put into their work, say 'aaahhhh' whenever they unleash a new experiment and hail them as being the original pixelmasters.

SODAPLAY

British design collective Soda enjoyed unprecedented success with
their addictive net toy, the Soda Constructor. The site registered
over a million users in its first month. Soda have proved that great
interactive content can keep people coming back and that email
is a great viral marketing tool. The group continue to modify the
site, building in improvements that users request, such as exhib-
iting the best constructions in the Soda Zoo. As a result they have
created a large and loyal community around the project. The
Constructor has a strong yet simple aesthetic that stands out as
a truly original application.

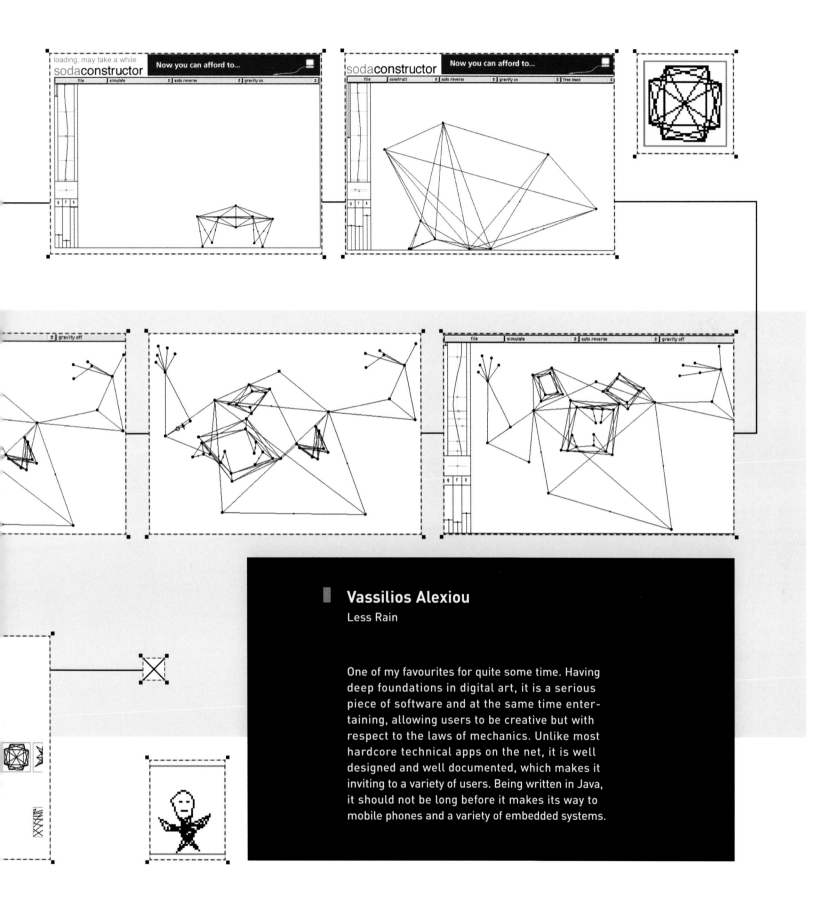

Vassilios Alexiou

Less Rain

One of my favourites for quite some time. Having deep foundations in digital art, it is a serious piece of software and at the same time entertaining, allowing users to be creative but with respect to the laws of mechanics. Unlike most hardcore technical apps on the net, it is well designed and well documented, which makes it inviting to a variety of users. Being written in Java, it should not be long before it makes its way to mobile phones and a variety of embedded systems.

058 PLAY

WWW.MODIFYME.COM

design
JAMES TINDALL

function
EXPERIMENTAL

technology
FLASH

MODIFYME

A much more absorbing sound toy than most. Users must select elements to play with according to their processor's power. Once selected, different sound samples flow across a grid to the beat. It's rather soothing watching the interactive icons flock, bounce and blow across your screen. Modifyme is a break from the usual fierce techno toys. This site really shows just how far play has come in the past five years; re-skinning games like Pong and Pac Man just doesn't cut it any more.

Josh Ulm

io research

As the internet – the now pre-eminent birthing ground for would-be interactive work – continues to grow up, digital audio remixers are quickly taking their place as another website staple. Two sites, www.modifyme.com and www.leftfield-online.com (see page 126), continue this evolutionary lineage with their own twists on user interface, mixing effects, and of course, unique visual design. Both remixers were designed by James Tindall of squarerootof-1.com

fame. Leftfield was created in conjunction with Kleber, the London interactive group known for work on music sites such as Warp Records and Ninja Tune. As well as having the same creator, both sites require a set of instructions to understand their unique interfaces. The ability to navigate Modifyme comes only with sufficient exploration and patience. Given a healthy interest, the systems finally shed their foreign exteriors and the sounds inside start to take shape.

Danny Brown
Mr Noodlebox

Although this site uses the web as the delivery medium, it is itself independent of the web, and its design reflects this – it is a self-contained product, an object of art that is quantifiable in the same way that I can appreciate a piece of art irrespective of the gallery it's in. It doesn't mix technology and try to show off many different things, it aims to be one thing and one thing only.

It is a new genre of music instrument – it is not a gimmick with simple sound samples that one throws on to a website, it stands alone.

As a visual music-making tool, it is an enabler for people who wouldn't normally have access to musical instruments, or who don't have the knowledge needed to play them. People can use Modifyme and very quickly see the visual and audio relationships, and I think that itself enlightens the user.

I think we're looking at a new era with the internet where rather than just brochure-ware takeaway information sites, we're seeing actual art objects presented through the web. I can see a whole market for these kind of tools/toys/objects taking off, a new form of entertainment, and this is a pioneering piece in that respect.

How often do I use it? How often do you use a painting on a wall? Just because I'm not standing in front of it with a glass of red wine doesn't mean it isn't being art. From another angle, being a Zen-head, I find it an immensely satisfying toy for clearing my head – almost hypnotic, trance-like.

I spend five to ten minutes each visit. I use it at home, but it would be great to see it presented in a gallery environment.

SAFEPLACES

Safeplaces presents the user with a selection of Flash and Quicktime projects, from the edgy to the sublime. The aim is to simply play, watch and interact. These experiments are often more engaging than full-blown games, which demand a great deal of time and effort on the part of the user. Safeplaces hints at the depth of interactivity that we can soon expect to see on the net.

'Milk & Honey' : Burger/Ink

Vassilios Alexiou

Less Rain

Safeplaces is beautiful. It has its own narrative which evolves with time, rollovers and clicks triggering different things, all contributing to an audio-visual space that is comforting and sweet. While the interaction language is very simple (e.g. click and drag is rarely used), it manages to engage to such an extent that you end up clicking the same thing dozens of times – proof that we are all somehow missing that sort of sweetness in interactive media. Hud and City share the same characteristics as Safeplaces but to a lesser extent, their more 'contemporary' design style somehow rendering them less emotional. I would like to see more sites like Safeplaces.com, going further than an all-singing-all-dancing illustration, taking more risks with interactivity, narrative and content.

SHARE

Sharing is one of the founding principles of the internet. While many aspects of it – sharing technical knowledge, sharing views, sharing experiences – are represented elsewhere in this book, here we have a small selection of sharing ideas unique to the web. The spectacular rise and even more spectacular comeuppance of Napster is a vivid case in point – this could not have happened elsewhere.

NAPSTER

Napster needs no introduction. Even high-profile court cases have failed to put an end to the largest community on the net. Over fifty million people have downloaded a free copy of the music file sharing program, allowing them access to each other's music collections. In Napster's community each computer acts as a server to others on the network, thus bypassing the need to store the music files in a central location. Napster sticks a defiant two fingers up at the record companies whose domination of the music industry might well be coming to an end.

Download Napster Now

Find out why Napster is the hottest application on the Net — download it today. We are constantly working to improve the quality of our software. Check back here from time-to-time to download a new version.

Choose your Flavor:

Napster for Windows
Latest Version: 2.0 beta 9

Napster for the Mac
Latest Version: 1.0 beta 1.1

Find out more about the application that absolutely everyone has been talking about. Check out screen shots, reviews, or just download it.

Mac fans rejoice! Napster for the Mac is finally here, and with tons of great features. Peep the latest reviews, screen shots, or just get it now.

Copyright 2001 Napster Inc. All Rights Reserved

"The amount of time companies spend stressing about getting a record on radio, you would think that the idea of some big, global listening post would make perfect sense... " -- Damian Harris (owner of SKINT, Fatboy Slim's label)
<< more >>

Home
Download
Speak Out
Discover
Press Room
Help

Service Status
Company
Policies

Newsletter
Your En
Subscribe

Welcome to Napster

Join the largest, most diverse online community of music lovers in history by downloading and installing Napster. It's fun, simple, free, and available for Windows and the Mac.

update available!

News Flash!

Purchasing music you discover through Napster is more convenient than ever. Our latest software upgrades for Windows and Mac link directly to CDNOW! **Upgrade now!**

Featured Music

Dave Matthews Band

Be among the first to travel new territory charted by **Dave Matthews Band** in their much-anticipated fourth studio album, EVERYDAY. The first single, "I Did It," features Dave on lead vocals and baritone guitar, the entire band on backup vocals, plus a special vocal performance from violinist Boyd Tinsley. more...

What's Going On?

· **Newsletter**: Did you miss the latest Newsletter? Read our Archives.
· **Q & A** on the Napster/Bertelsmann alliance.
· **Napster is Hiring!**

Copyright 2001 Napster Inc. All Rights Reserved

Eric Rodenbeck
umwow

HTML websites are generally caught between two equally destructive forces: web designers, who are trying to give people something to look at and a reason to stay, and marketing weenies, who reject outright any gesture, look or content that might cause a visitor to actually want to pay attention to what's in front of them. In the scuffle, the thing gets dominated by a discrepancy

in the way in which people deal with content-less-ness (vacuity). Napster is one of those few sites that seems happy for people to come to the site, get a basic sense of what's going on, and then go on to something else which is much more interesting: sharing music with a wide community of users. This shows you what can happen when you actually have something to say.

The assumption is that people are at the site because they want to be, and that they know something about the company and the service it provides.

Essentially they have the luxury of simplicity; they don't have to dress up their message in marketing speak.

STICKERNATION

Getting something for nothing is what the net is all about, and at Stickernation you get, you guessed it, stickers. Swapping stickers in the playground was a popular pursuit in the 1970s, now in the 21st century designers can harness the power of the net to share their sticker designs with the world. All visitors have to do is print their favourites onto sticker paper – a cheap way for anyone to own cutting-edge designs.

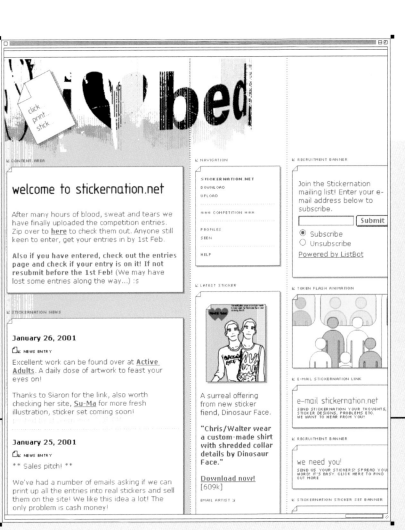

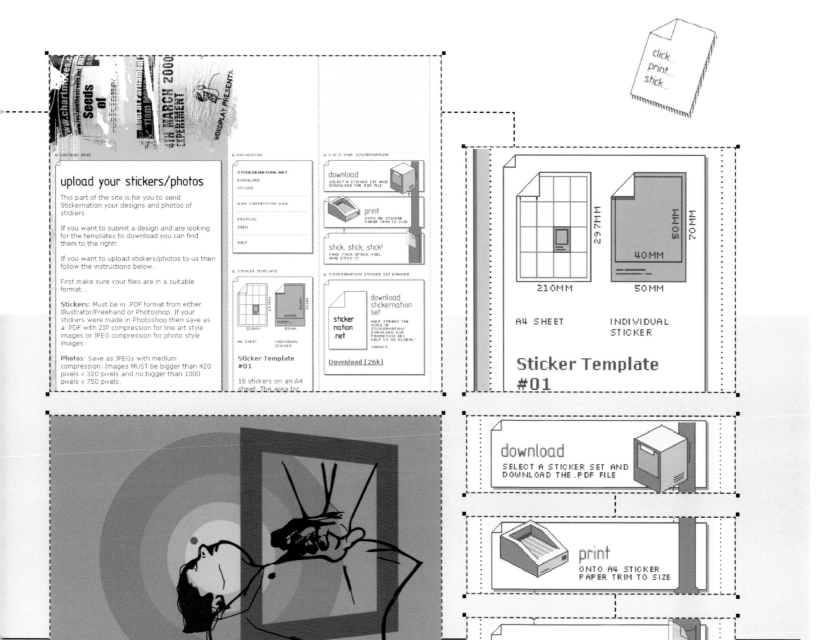

WHITE NOISE CENTRAL

White Noise Central is an online diary that follows the experiences of two music writers, Jim and Matt. Updated daily, the duo write about their pasts, the present and the future. The web has many such places where people share their innermost thoughts, family and pets with the world – they appeal to the shameless voyeur in all of us.

WHITE NOISE CENTRAL dot org [v2.0] 28:JAN 01

home | submit | email us | links

▮ R R NAVIGATE HERE

entries 0

year

01 02 03 04 05 06 07 08 09 10 11 12 13 14 15 16 17 18 19 20 21 22 23 24 25 26 27 28 29 30 31

The point at which White Noise Central becomes a community, this page is an invitation to contribute words, images and sounds.

If you feel like blowing the virtual world away with your creative outpourings, use the form provided to send text, or write an email if you want to send sound or image files, attaching the relevant goodies.

Each submission comes complete with an about box, so if there's any information about yourself that you feel that people looking/listening to your stuff should know (eg. other URLS where your work is on display, your attitude towards small mammals) then please include it with your submission. We want to make whitenoise as interesting and varied as possible, so the more voices screaming madness in pixels the merrier.

MUS DOMESTICUS, SO GOOD THEY NAMED IT MICE

Home :: Links

LINKS
A FEW SELECT SLICES OF THE INTERNET CHEESECAKE

SUBMIT
GET INVOLVED IN WHITENOISE – TXT / IMG / SND

Name:

Email:

Text:

submit ▶▶ clear ✕

🖲◇🖲 About The Words We Like

Blues for Peace
Gateway to a world of strangeness-check out the beats stuff.

Solid|Type
Judge a book by it's cover.

Techfonts
Pixel fonts are go!

The Modern Word
Loads of stuff on our spun-out b
Joyce et al

Vonnegut Web
Funny, smart, and completely devoid of pretension.
Ding-a-ling, Mother-fucker!, Ding-a-ling!

🖲◇🖲 Art & Stuff

Memoirs from Hijiyama
Lest we forget...

The ICA New Media Centre
Web art in the new millennium, I

🖲◇🖲 Cute Pixellated Sites

EBoy
Badd-asss pixel punch-up in aliased icon land

Flip Flop Flyin
Cute pixel buddies

Icon Factory
Small pixellated icons are fun

Icon Town
Where all the cool pixels hang o

Mobiles Disco
Where the funky pixelkind get together

NetBaby World
Cute as a digitised baby tiger

QuickHoney
Dip your sticky mits into a lovely pot of pixels

Sticker Nation
Cool kids stick stickers.

Word.com
Where would we be without the WORD?

CHAT

To 'chat' implies a form of communication that is trivial. That chatting has become one of the most popular activities online is proof to some of its immaturity, yet our research has revealed that the web does provide a forum for serious exchanges of views on serious matters and even a means of conducting meetings between colleagues in different countries. Chatting is no longer an idle pursuit.

DREAMLESS

Joshua Davis, the New York-based designer behind PrayStation, is also the creator of this design community discussion site. Davis has said that although the discussions are about serious design issues, he wanted the site itself to have almost no design. Deliberately muted in tones of grey, Dreamless illustrates how a site can be very simple yet also beautiful. As with many forum sites, discussion streams are often started by moderators, with users responding and building the debate from there, tapping into the communal nature of web design where progress is made through sharing ideas and, often, fierce argument.

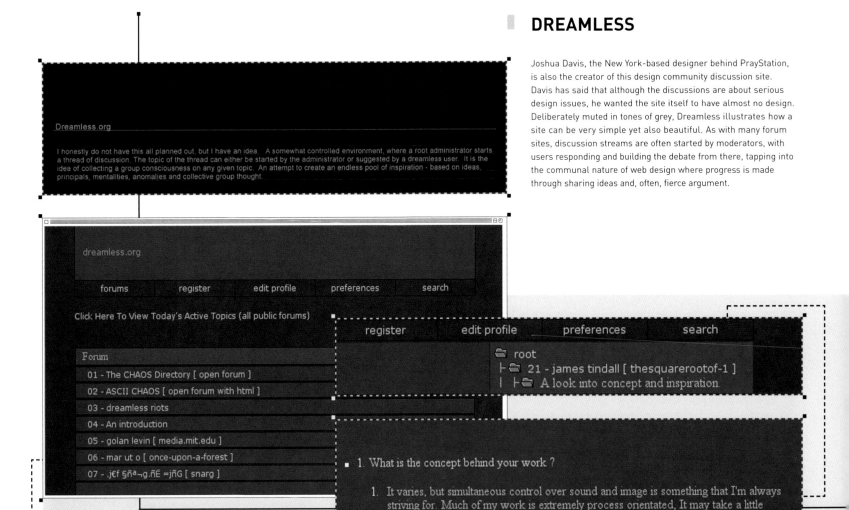

George Shaw
onetendesign

Dreamless.org uses a very common bulletin board (UBB) as its underlying engine. This is a huge advantage in that the fundamentals of how the board works are already very familiar to most people who have spent any time on other message boards. Dreamless benefits from the years of trial and error, feature adding/subtracting, refining, etc. that have gone into UBB. At the same time, though, Dreamless is designed visually from scratch (none of the generic buttons and graphics remain from the original UBB). The design is perfectly simple, yet absolutely functional – only shades of grey are used. The way the content itself is designed uses similar methodology stripped down to the few pieces of pertinent information that people really need. I'm not sure if it's just me, or if it's just because I tend to relate to the folks who frequent (and maintain) Dreamless, but somehow the site just absolutely clicks for me. I find it extremely intuitive ... even surprising in its usability.

CHAT

design
MATTHEW HAUGHEY

function
CHAT ENGINE

technology
COLD FUSION,
MYSQL, HTML

073

WWW.METAFILTER.COM

METAFILTER

Metafilter bills itself as being 'more addictive than crack'. It is a 'weblog', a small site with regular users focused around one theme or concept. At Metafilter, anyone can contribute a link or send in a comment to chat streams which cover topical news stories or issues. Design-wise it's nothing special, the attraction comes from the content – arguing with someone on another continent.

Michael Schmidt
k10k

Where Dreamless.org stops, Metafilter takes over. It's one of the best no-holds-barred, totally uncensored, news-flowing-everywhere kind of discussion sites out there. It's completely addict-ive and (probably) better than crack. The Metafilter design is not much more than a slip dress that's barely big enough to cover all their content, but it works, it's fast, it's functional and it supports the concept of the site extremely well.

PLAYDO

Playdo takes a more fun approach to the whole chat thing, with its stated intention 'to make people on the net interact and communicate in a nice and friendly environment'. As usual, you build a character from a menu who then becomes a citizen in Playdo city. There you can 'gossip over coffee, send mail, get challenged in an online-game, get friends, rent a private detective, go to your room and put on your favorite dress for the nightclub-party, etc.' After its first six months, the site had over 23,000 registered citizens, a figure achieved without the benefit of any marketing campaigns.

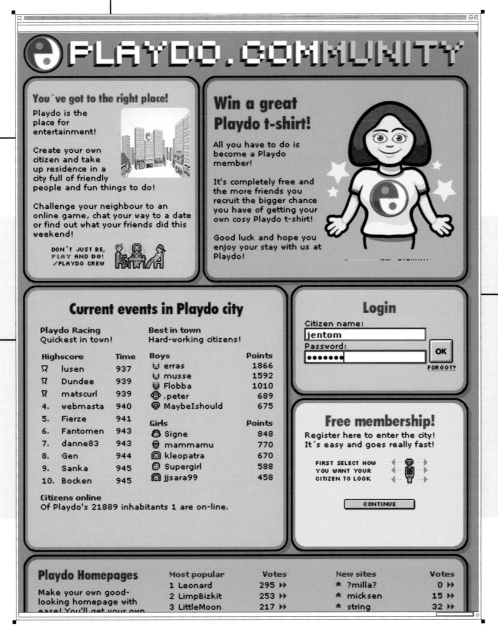

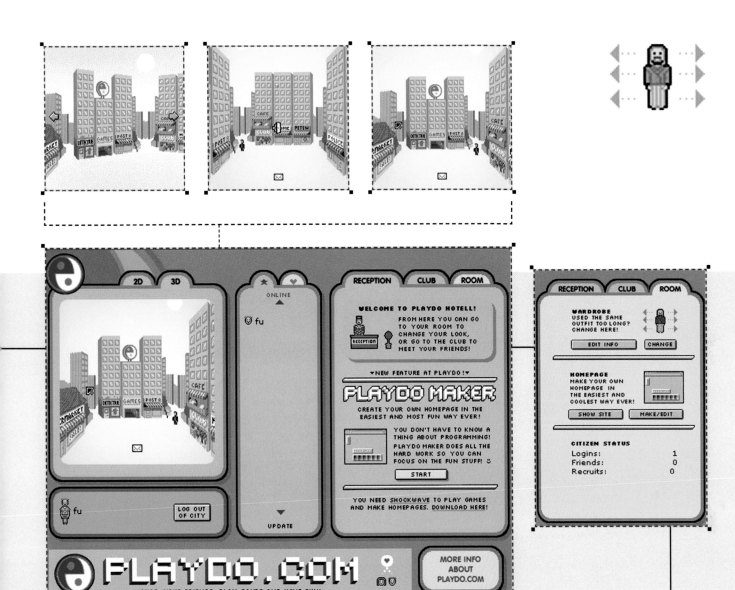

Craig Robinson

flip flop flyin'

Very very cute. A super way to make
chatrooms less 'texty'.

HABBO HOTEL

Habbo Hotel is from the people behind Mobiles Disco and continues its character-based chat. Users pick an identity from a menu of facial characteristics, hairstyles and wardrobe, then enter one of the rooms in the hotel where they can talk to any of the other guests. Though essentially playful, the serious possibilities of this technology are starting to be explored: why videoconference when you can meet up in a cool lounge for a multinational get together?

Annette Loudon
niftycorp

Habbo Hotel is a rare combination of robust functionality and style. It's a very sophisticated chat app that has clearly had a lot of thought and a lot of work (and play) put into it. At first glance you might think it's just an expanded version of Mobiles Disco (Sulake's first graphical chat), but after spending a little time in there it becomes clear that the application has evolved significantly. They've obviously paid a lot of attention to users' feedback and put that information to good use when designing Habbo Hotel. More often than not, graphical chats wind up being slightly less functional than a basic text-based chat, and the graphics become more of an impediment than an enhancement to the experience. Habbo Hotel proves that this doesn't have to be the case and we finally get to see what a difference graphical avatars and space can make to social experiences online. Avatars give another dimension to our online personas and provide social cues. Outfits and decor provide social props that are missing from text-based chat, making it easier for people to start up conversations in a way that feels more natural than the now legendary phrase 'how old are you?'.

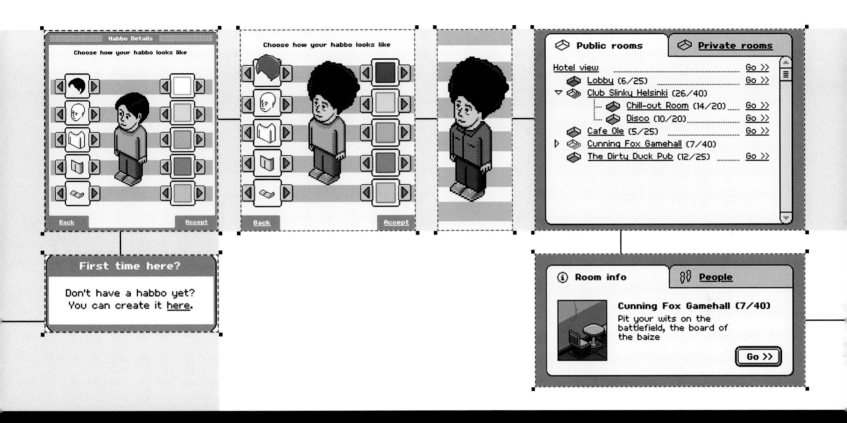

In text-based chats, multiple conversations are intermingled, and often difficult to follow. And in bubble chats the chat environment is usually quickly obscured by text. But in Habbo Hotel you only see the full conversations of those in your immediate proximity. Other people's chat is only seen in snippets – the visual equivalent of crowd noise. It's a very smart adaptation of a trick previously only used in voice-chats (and reality). It also attempts to maintain context by having the chat bubbles stack on top of one another as text in a text chat would do.

The pixel style has been done to death recently, but the style makes a lot of sense for an on-line environment. It packs a lot into a small space, and the floor grid makes for very intuitive navigation. And Habbo Hotel's attention to detail makes it one of the best in its genre. Perfect little people, perfect little lounge chairs, perfect little trees with perfect little oranges. And don't get me started on the amazing floor to ceiling water sculpture in the lobby! Sulake have obviously had a lot of fun creating this, and that playful energy is part of what makes Habbo Hotel such an inviting space.

I hang out there with friends who live in other cities and countries. More recently I've been meeting people to talk about projects we're working on together. It saves on long-distance calls, and it's a lot easier to resolve tricky problems in real-time rather than over a bunch of emails. Lately I've been visiting about three times a week. I usually spend about three quarters of an hour.

It's growing into a real community. If you pop in from time to time you'll begin to recognize people. That's a pretty amazing achievement for such a free-form chat space. The graphical avatars, spatial elements and activities are all coming together to create a very natural social space.

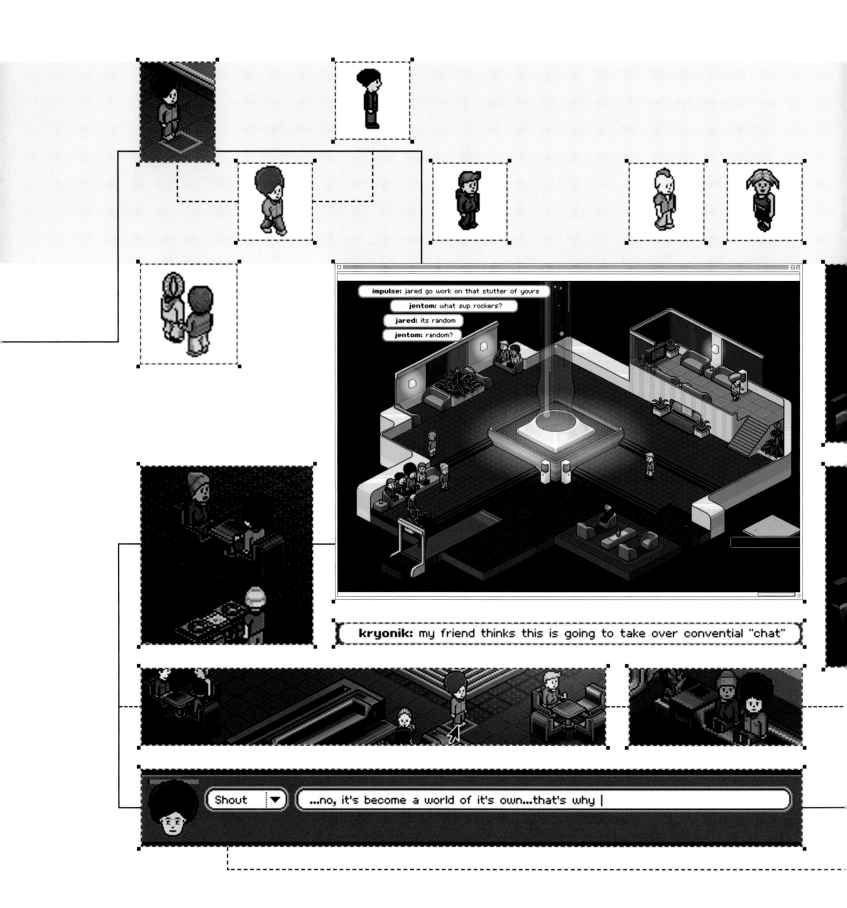

impulse: jared go work on that stutter of yours

jentom: what sup rockers?

jared: its random

jentom: random?

kryonik: my friend thinks this is going to take over convential "chat"

Shout ▾ ...no, it's become a world of it's own...that's why |

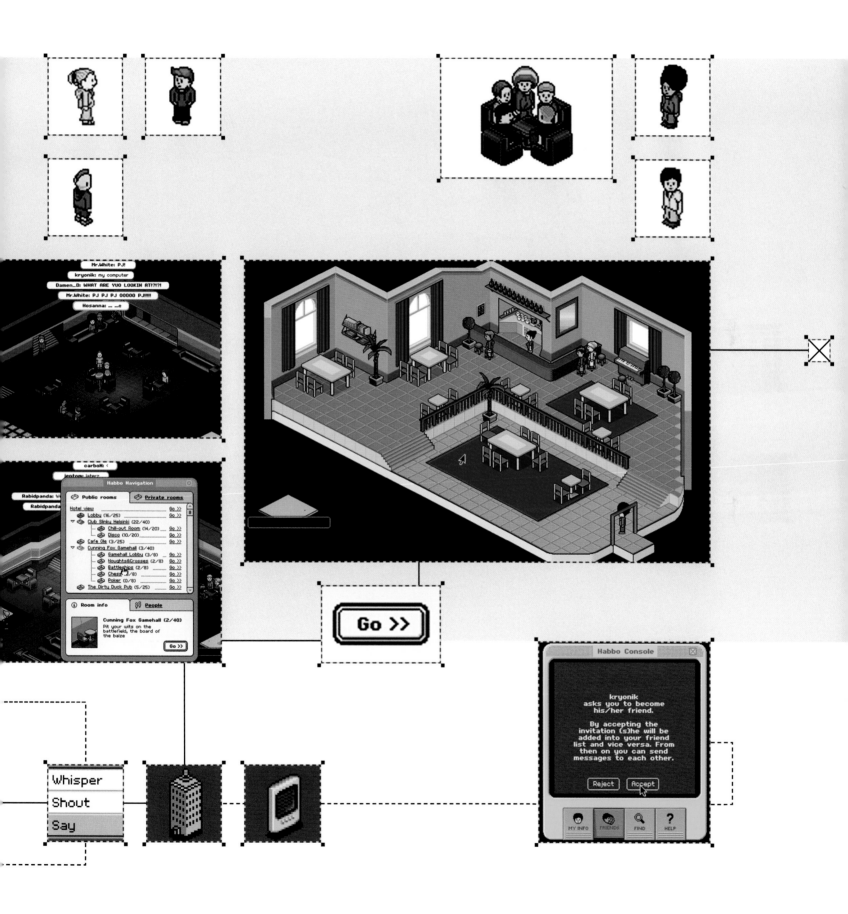

Mr.White: PJ!

kryonik: my computer

Damen_D: WHAT ARE YUO LOOKIN AT!?!?!

Mr.White: PJ PJ PJ OOOOO PJ!!!!!

Hosanna: ...e

carboN: ‹

jentom: laterz

Rabidpanda: W

Rabidpanda:

Habbo Navigation

Public rooms | Private rooms

Hotel view

Lobby (16/25) — Go ››
Club Sinku Helsinki (22/40) — Go ››
— Chill-out Room (14/20) — Go ››
— Disco (10/20) — Go ››
Cafe Ole (3/25) — Go ››
Cunning Fox Gamehall (3/40)
— Gamehall Lobby (3/8) — Go ››
— Noughts&Crosses (2/8) — Go ››
— Battleships (2/8) — Go ››
— Chess (1/8) — Go ››
— Poker (0/8) — Go ››
The Dirty Duck Pub (5/25) — Go ››

Room info | People

Cunning Fox Gamehall (2/40)
Pit your wits on the battlefield, the board of the balze

Go ››

Go ››

Whisper
Shout
Say

Habbo Console

kryonik
asks you to become
his/her friend.

By accepting the
invitation (s)he will be
added into your friend
list and vice versa. From
then on you can send
messages to each other.

Reject | Accept

MY INFO | FRIENDS | FIND | HELP

design	function	technology
THE STAFF AT WORD	CHAT ENGINE	SHOCKWAVE, LINGO

SISSYFIGHT

Sissyfight is a hilarious hi-tech take on playground bullying. It's a place for trash-talking little girls to gang up on one another in a vicious re-enactment of childhood. As with other character-based chat sites, users assume an identity before entering the arena and interacting with whoever else happens to be online. Viciously addictive and very disruptive when played in an office environment.

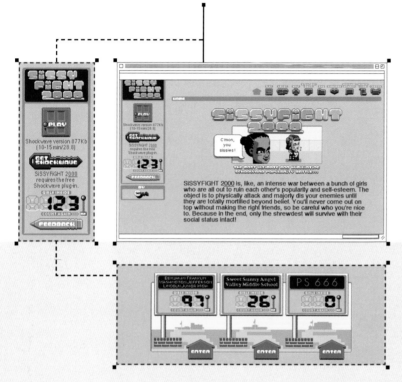

Yoshi Sodeoka

word.com

I was the art director for the site so I do have an interest, but it's a good chat engine too because the chat could be based on the game, and the game itself is pretty emotionally intense, so users actually make friends in there.

There's a big community around the game now, even though there's no one maintaining the site any more.



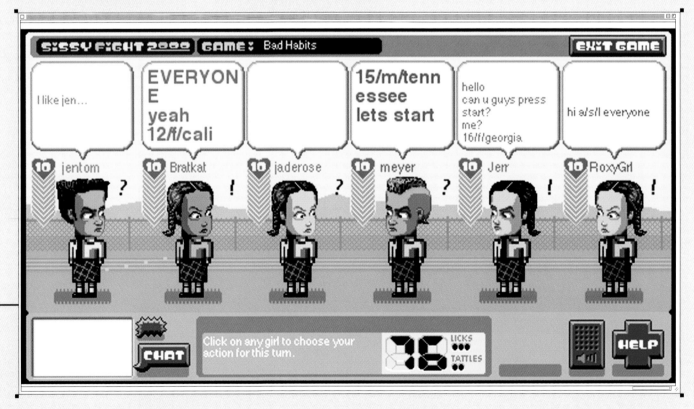

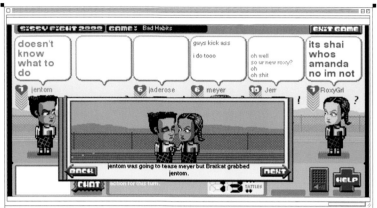

Jerr tattled! Bratkat and jaderose and jentom and meyer and RoxyGrl got in trouble.

RESULTS

Jerr and RoxyGrl became best friends and won the game! Jerr earned 80 points and RoxyGrl, 120 for defeating 4 girls.

jentom and meyer and Jerr and RoxyGrl got 10 points just for playing.

EXIT GAME

design	function	technology
I-D MEDIA	CHAT ENGINE	OBJECTIVE-C, JAVASCRIPT, INFORMIX DATABASE

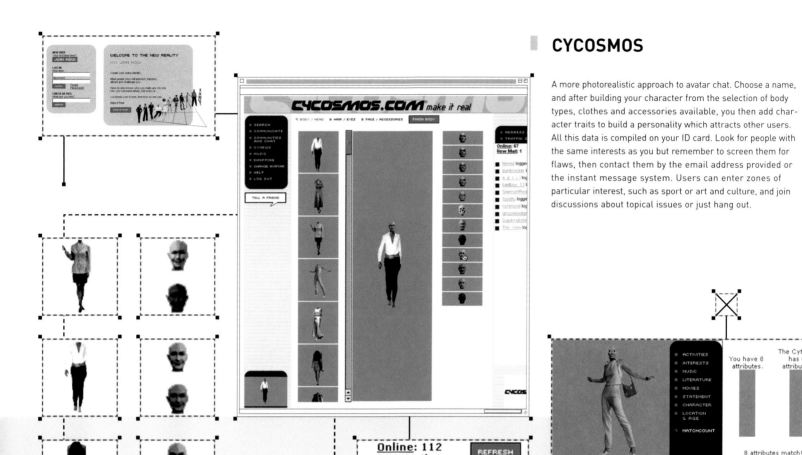

CYCOSMOS

A more photorealistic approach to avatar chat. Choose a name, and after building your character from the selection of body types, clothes and accessories available, you then add character traits to build a personality which attracts other users. All this data is compiled on your ID card. Look for people with the same interests as you but remember to screen them for flaws, then contact them by the email address provided or the instant message system. Users can enter zones of particular interest, such as sport or art and culture, and join discussions about topical issues or just hang out.

Matt Uber
Tripledash

I like the fact that Cycosmos allows you to be a chameleon; you can change the way you look and the way you talk to people depending on your mood, almost like attending a fancy dress party.

It is focused on you as a living part of the community, allowing you to change your look and talk to people while maintaining your sense of place. It's the only place around that makes you feel like a human rather than a cartoon character.

What makes it 'beautiful'? The level of detail and variety in your choice of avatar is amazing; I particularly like being a fat man with a beard in dungarees standing in front of a wheel-barrow.

This site isn't really about being useful, it's about having some fun and talking to people, which has always been the best part of the web for me.

I usually check in about once a week, just to get some perspective on how people other than the new media crew view their lives and particularly the web: I usually spend half an hour or more and it's almost always at work. The interface that lets you change your body features is simple but fantastic. A real Frankenstein experience.

SMS MESSAGING

When text messaging or Short Message Service to give it its proper name, was introduced to mobile phones in 1999 no one thought it would be a particularly popular feature. Phone companies were so dismissive of it that many didn't even mention it in their instruction books. The Next Big Thing was going to be WAP, everyone was agreed. Things didn't quite work out that way. WAP has not lived up to expectations, whereas SMS went stratospheric. An estimated 200 billion text messages are now sent each year. The UK has been one of the most enthusiastic adopters of the technology with a record 929 million messages being sent by 30 million users in January 2001. Virgin mobile reports that average users send 20 to 40 messages per month, heavy users send 3000. SMS allows users to exchange up to 160 characters between mobile phones. It has spawned its own language and its own art as experienced texters have learned to draw crude images using the limited character set available. Xtremetext.com showcases some of these artworks in its gallery section – the site itself promotes a new model mobile from Motorola, the v.box, with a flip-top keyboard designed especially for texters. So far, the heaviest users have been teenagers using the service to communicate with friends, especially in class, but its potential has not gone unnoticed by commercial organizations. In the UK the Sun newspaper used SMS for a bingo game and had 80,000 responses. Lakeside shopping centre used it to tell customers of special offerings. Even Amnesty International has recognized its power, encouraging supporters to text message politicians instead of signing petitions. Expect to see a host of SMS marketing campaigns as agencies begin to exploit a means of sending messages direct to targeted consumers. SMS must be the most unlikely success story of all digital media, but it has also been one of the biggest.

@ at	**ATB** all the best	**B** be, bee	**BCNU** be seeing you
BWD backward	**B4** before	**C** see, sea	**CU** see you
DOIN doing	**F2T** free to talk	**FWD** forward	**GONNA** going to
GR8 great	**H8** hate	**L8** late	**L8R** later
LUV love	**MOB** mobile	**MSG** message	**NO1** no one
NE any	**NETHN** nothing	**NE1** anyone	**PPL** people
OIC oh, I see	**RGDS** regards	**PLS** please	**STRA** strange
RUOK are you ok?	**THX** thanks	**SUM1** someone	**UR** you are
THNQ thank you	**W** with	**U** you	**WKND** weekend
WAN2 want2	**2** to	**W/O** without	**2DAY** today
XLNT excellent	**2NITE** tonight	**YR** your	**2MORO** tomorrow
1 one, won	**PCM** please call me	**4** for	**XOXOX** kisses & hugs

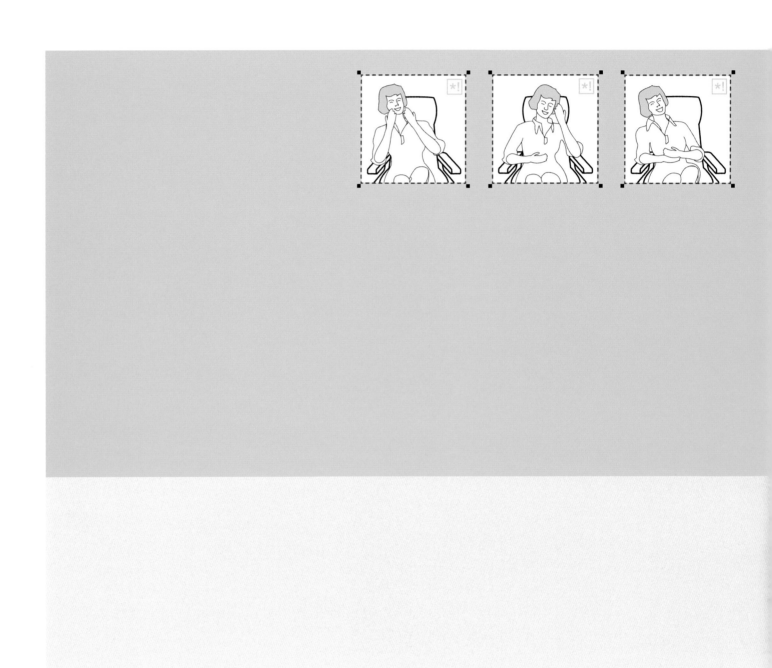

LAUGH

The web is a great repository of humour – intentional or not. Independent content providers go to great lengths to entertain and in so doing can attract huge audiences as the 'have you seen this?' factor comes into play via emailed URLs. (Such 'viral' methods are now being appropriated by marketers.) Personal sites, created in spare time and devoid of corporate sponsors, become cult phenomena on the web, attracting the kind of buzz that big brands would die for.

FLIP FLOP FLYIN'

The cult of the pixel is alive and well at Flip Flop Flyin'. The site is a personal project by Craig Robinson. It is a labour of love and a testament to one boy's love of pixels – which coincidentally is a tale featured on the site. In addition to desktop downloads and a mini version of the Museum of Modern Art, Robinson has created hundreds of tiny images and GIFs of celebrities from the Backstreet Boys to the Beastie Boys. Though only a few pixels wide, Craig's miniature portraits succeed in looking remarkably like the celebrities.

Featured here from left to right: Bob Marley, Dr Evil and Mini-me, Margaret Thatcher, The Beatles, the Dalai Lama, Fidel Castro, Britney Spears, The A-Team, A Clockwork Orange, David Hasselhoff, Plastikman, The Breakfast Club and Eminem.

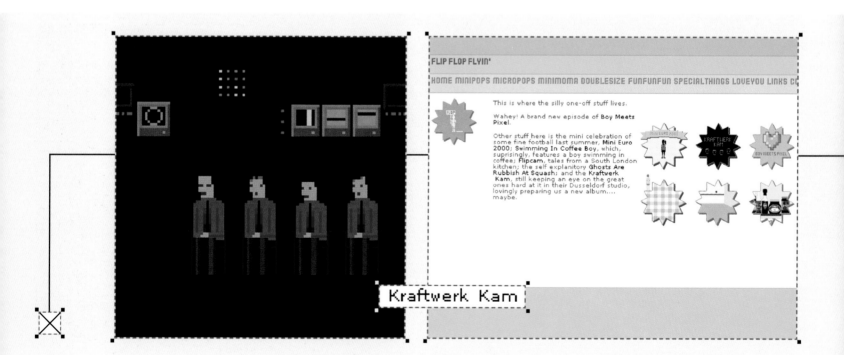

Kraftwerk Kam

FLIP FLOP FLYIN'

HOME MINIPOPS MICROPOPS MINIMOMA DOUBLESIZE FUNFUNFUN SPECIALTHINGS LOVEYOU LINKS

22 January 2001

GOODBYE CIGARETTES, I LOVE YOU

There'll always be the memories...

There's some new **Micropops** today. And, nicotine chewing gum tastes horrible; my mood is kinda swingy; apologies if you've had trouble accessing the site over the past few days, there's been problems at the hosting end of things; **'Cast Away'** is a good film, even when dubbed into German; a new episode of Boy Meets Pixel is nearly ready; and I still hate **Pixelpark**. That's it, really.

Recent meanderings:
19 Jan 01: Tupperware & theft.
15 Jan 01: Minipops.
12 Jan 01: Love songs & MTV.
09 Jan 01: New old stuff.
18 Dec 00: I'll be home for...

There's some new **Micropops** today.

FLIP FLOP FLYIN'

HOME MINIPOPS MICROPOPS MINIMOMA DOUBLESIZE FUNFUNFUN SPECIALTHINGS LOVEYOU LINKS

Welcome to Micropops, the rather sexy little sister of Minipops.
Micropops is where you can have your work displayed for all to see. If you feel like creating a mini pop star, a mini sports dude, a mini film star, a mini self-portrait or a mini picture of your mum, then Micropops is the place to be.
Lots of people have already submitted their creations, and if you want to join them in making famous, or not-so-famous people real small, then get creating!
Let your imagination flow. Micropops is your place.
Only one rule: No Manchester United players.
Email your Micropops to me - in GIF or animated GIF formats only, please - and they'll soon appear for all to see and admire.
Thank You.

Email: *craig@flipflopflyin.com*

New Micropops >
22 January 01. By Andre, Ashley, Miguel, Rob, Substance, Tabatha and Yellow Ant

Micropops A - E >

Micropops F - M >

Micropops N - Z >

Micro Elvis>
A tiny celebration of The King.

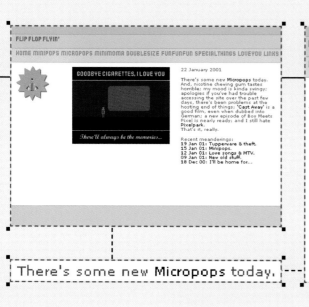

MICRO POPS

Micropops front page

New Micropops
Micropops F - M
Micropops N - Z

ADAM KOFORD:
"Futurama"

ADAM SHAW:
Boba Fett

ADRIAN SCHULTHESS:
Catpower

AEROFLOT:
Ladytron

AGATHA LENCZEWSKA:
Self Portrait

ALBERTO RODRIGUEZ:
Callaghan, Harry
Manero, Tony
Marley, Bob
Romero Cantador, Carmen

■ **Damian Stephens**
Type01

You have to marvel at the amount of work that has gone into the studies of everyday life in Craig's beautiful micro-pixel world. In his own words, 'Nothing fancy, just normal stuff'. Flip Flop Flyin' contains beautifully observed, unbelievably detailed and expressive animated GIF 'movies', the legendary Minipops (tiny pixel celebrities), Micropops (submitted by users) and various other pixel paraphernalia. Any site that extensively uses pixels and animated GIFs is a winner with me.

HOT OR NOT

Visitors to Hot or Not? rate photographs of men and women on a scale of 1 to 10. These votes are then displayed as an average score. The people who appear on the site are of course either not at all hot, in love with themselves or both – it wouldn't be fun otherwise. Hot or Not? have used their content as a base to build up a community chat room that expands at a rate of 150 new members a day.

Please select a rating to see the next picture.

○1 ○2 ○3 ○4 ○5 ○6 ○7 ○8 ○9 ○10

NOT ▬▬▬▬▬▬▬▬▬▬▬▬▬▬ HOT

How hot are YOU?
Submit your picture and find out!

Justin Cooke
Fortune Cookie

In the tradition of all great things, hotornot.com allows you to laugh at someone else's expense: it's fun to do and it's insanely addictive. Some say that the key to its popularity is its simple interface. Hot or Not has only the most basic design, it is incredibly simple and is all focused to perform only one function: click a number, get a result – a one click wonder.

There is something very empowering or enabling about it. That you can make a difference, your voice can be heard without having to register or reveal your email address. It allows users to participate, contribute to a greater whole without any complexity or stages of completion.

Some would say that Hot or Not embodies the fundamental strengths, some would say romanticisms of the web. That two ordinary guys can have an idea and in eight days change the world.

I use it to escape, to laugh and to participate. I use it at work when no one is looking or when I have had a few drinks with a few friends on a Friday evening.

THE ONION

Satirical e-zine, The Onion, is proof that great content can be text based and free (a paper version of the magazine is available on subscription). The Onion is the perfect lunchtime treat, the sheer volume of utter rubbish is enough to keep users coming back for more. The Onion has gone one step further than some other spoof sites – its design is a parody of 'serious' news magazines. Jakob Nielsen would be proud of the results.

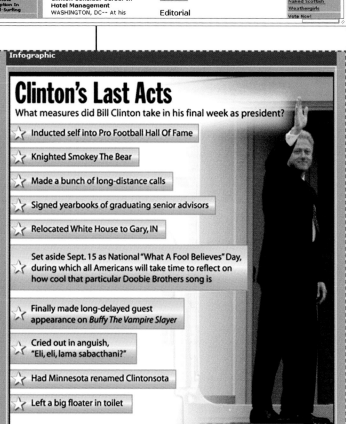

Winner Didn't Even Know It Was Pie-Eating Contest

Ape Footage Causes Brief Three-And-A-Half- Minute

TRAVEL

Though using the internet can be a journey in itself – hence all the 'surfing' and 'exploring' metaphors that are so overused now – it also features a great deal of content relating to travelling in the real world. Here we have selected three sites from our respondents' submissions which are representative of typical approaches to the subject online: the airline ecommerce site, the guide book and the interactive tour which aims to convey the essence of a city through a mixture of moving image, stills, graphics and video. Travel the world from the comfort of your desktop.

094 TRAVEL

WWW.LUFTHANSA.COM

design

function

technology

LUFTHANSA
ECOMMERCE

COMMERCE

HTML

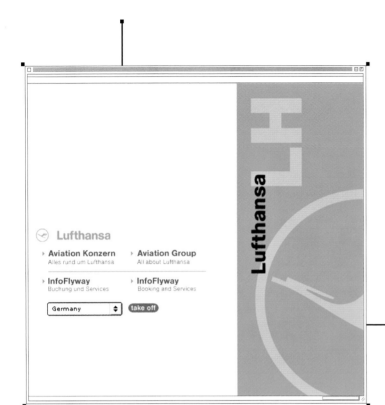

LUFTHANSA

For major companies, devising some kind of web presence rubs up against the crucial question of translating carefully nurtured brand values and corporate identity into a new medium. Lufthansa manages this better than most. This is a very straightforward site which typifies the functionality found in this sector: users can book online and check the status of their air mile accounts. More interesting for a creative audience is the photo gallery (increasingly a feature of corporate sites) containing an archive of historical and modern images of planes and airports. The Designers Republic have used some of these images in their recent work.

Daniel Jenett
Razorfish

I visit websites for the function/service they provide to me. The aesthetics are completely secondary. Mostly I stay with one brand/website because I am too lazy to look around for more. If the design is good then I trust the place a bit more because I know how difficult it is to have a consistent and graphically pleasing running site. This site is well designed because it applies the corporate identity of Lufthansa to the online space. Type, colours and placement are consistent and in order. The architecture allows users to understand and reach the desired places or functions, and delivers the promise of a well maintained German airline. I use it to check my frequent flyer miles: the miles calculator allows me to see where I can go with my miles. All the Lufthansa company information is completely useless for me. I believe they are stuck in the mid-nineties when people confused websites with annual reports.

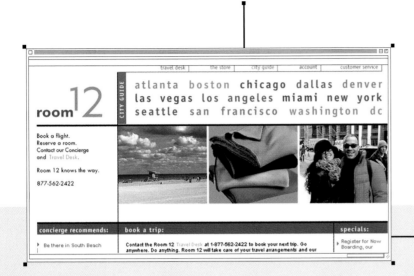

ROOM12

Room12 takes a glossy magazine approach to the travel website, which is unsurprising as its editor, Newell Turner, is a former Style Editor of Conde Nast's House & Garden magazine. It works as a sophisticated guide to some of the world's leading cities, catering to the needs of upscale travellers who, as the site says, 'have more money than time, who would rather be cool than comfortable'. At its best, it's like having a very well-travelled friend with immaculate taste to advise on your itinerary. As well as listing the coolest places to stay, eat and visit, Room12's concierge service will also handle booking for you.

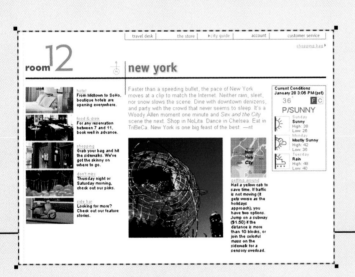

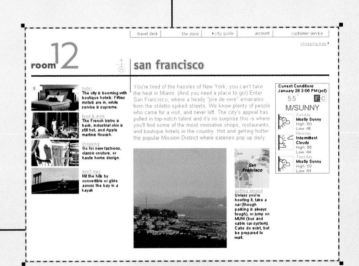

Jonathan Wells
ResFest

Room12 is like having a stylish friend in every major city in the US, who can give you the inside scoop on restaurants, hotels, clubs and shopping. I like the site's spare design, intuitive navigation and the fact that it doesn't overload you with info, but rather gives you a few select recommendations. While it often misses funky local standbys, if you are looking for new, hip and style-conscious spots, Room12 is on the mark.

MYCITY

Mycity is the web presence of an exhibition organized by the Banco do Brasil's Cultural Centre in Rio de Janeiro in 2000. Website designers from 43 different cities around the world were invited to produce a site about the city in which they live or were born. The result is an incredibly rich experience including work from some of the leading names in web design. The atlas-style interface is simplicity itself, especially in contrast to the highly innovative sites revealed by clicking on your chosen city. It is good to see an innovative web project that originates from outside the United States or Europe.

oslow
by
union design

oslow

OSLO

factbrowsing
boomtown explore

oslow

OSLO

factbrowsing
boomtown explore

Oslo - boomtown
by Erling Fossen

Despite the fact that during the past 30 years Oslo has been tentatively locked by the state in an iron corset, the city is today living a gold rush. In a seminar held some years ago at Yoksenåsen about the future of Stockholm and Oslo the former financial minister Per Kleppe bragged about how Arbeiderpartiet (Labour Party) managed to hold back the city growth in the last 30 years. The population of Oslo peaked at about 488.000 at the end of the '60-es, but this number sank before reaching half a million in 1997. In the early '90-es the state could not stop the city from growing any longer. While the government tried in vain to reverse the flow of people towards the capital and the local authorities attempted to create the basis for traditional industrial activities, one thousand multimedia and highly specialised firms were in a very short time established in Oslo. It is estimated that in 25 years Oslo has to build 100.000 new houses for 125.000 people. A growth of the same proportions is expected in the neighbouring areas as well. 43% of all Norwegian children are born in Oslo / Akershus.

next

map
bakersfield
book [earthquakes]
vegas strip
san francisco

Deer moat is a place which used to be a protection for the Castle in the ancient times. In present times it has already lost its original function, but it can still be a place where men can enjoy a supernatural experience. For example when at 3 o'clock in the night a bunch of young people, totally soaked by hard rain, dance together to the ambient rhythms of the Orb. That was the first dance festival called "Deer moat" last year - unfortunately it was also the last one, because the mighty ones of this town probably don't like young people having fun...

sanfrancisco
by
Eric Rodenbeck

BUY

Ecommerce sites such as www.amazon.com and www.ebay.com are seen as best practice models by the usability gurus and have been highly influential in establishing conventions, yet layout is often cluttered, sometimes confusing. Our respondents recommended some alternative approaches to shopping online where experience also comes into play.

BUYAROCK

The success of Amazon proves the web's suitability for purchasing low-cost standard items such as books or CDs where shoppers don't need to handle the goods before buying, but what about more expensive, personal items? Buyarock sells diamond jewellery. It has a campy, retro 1950s feel that at first may seem rather trivial when you are being asked to part with $5000 for a ring, but it does make for a fun experience that is far less forbidding than a visit to a high-class jewellers. It has a neat sizing chart to print out and plenty of background information on choosing the perfect diamond, but it faces quite a challenge in building enough trust to persuade customers to buy.

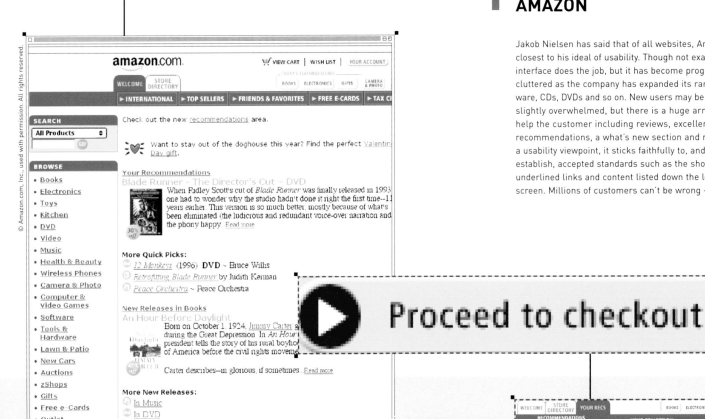

AMAZON

Jakob Nielsen has said that of all websites, Amazon.com comes closest to his ideal of usability. Though not exactly elegant, its interface does the job, but it has become progressively more cluttered as the company has expanded its range to include software, CDs, DVDs and so on. New users may be forgiven for feeling slightly overwhelmed, but there is a huge array of functions to help the customer including reviews, excellent search facilities, recommendations, a what's new section and much more. From a usability viewpoint, it sticks faithfully to, and indeed it helped to establish, accepted standards such as the shopping cart symbol, underlined links and content listed down the lefthand side of the screen. Millions of customers can't be wrong – can they?

Rob Andrews
Interbrand Newell and Sorrell

Amazon's a dull choice, I know, but I still think that it is one of the best sites on the web. It's not a great-looking site. It looks really old-fashioned and it's quite complex if you're not used to it, but when you get to functionality and content, it is the best thing on the web. It's a problem-solver, in the same way that a knowledgeable bookseller would be in a store: it gives me the confidence that if I ask for something, I'll get it. I can never remember birthdays, and their gift wrap service means that even if I only remember the day before, I can still look really thoughtful and prepared. I use it every couple of months for buying books, mainly for presents. If I'm starting from scratch and going through reviews to find something appropriate, I'll use it for anything up to half an hour.

John Simmons
Interbrand Newell and Sorrell

I visit it three or four times a day now to see what sales rank my book is, which makes me a bit of a sad addict; but apart from that little game I visit it to buy books because their service is great. It's great for tracking down more obscure books when bookshops are stocking a narrower and narrower range. They send me recommendations and they have a spooky understanding of the things I would be interested in.

BUY

WWW.LINETO.COM

design	function	technology		105
STEPHAN MUELLER, CORNEL WINDLIN	FONT LIBRARY	ACROBAT, FORMEL, SIMPLETEXT		

▊ LINETO

As with photo libraries, the web offers great opportunities to font libraries. Like images, fonts are a natural fit with ecommerce. They can be displayed accurately on screen and can be distributed easily via email. The web has enabled small, independent font designers to reach a global market cheaply and effectively. Lineto was founded by Cornel Windlin and Stephan Mueller (a.k.a. Pronto), two designers/art directors working independently in Zürich and Berlin. The site features fonts designed by these two as well as others around the world. In addition to retailing fonts, Windlin and Mueller also hope that the site will become a means of ex-changing ideas and a conduit for collaborative projects. Its interface rejects the pizzazz of other sites in this category in favour of the language of computer file directories which makes for easy navigation. Beautifully simple.

current directory is /lineto (version 2.2.1)

hello, visitor

welcome to www.lineto.com,
a department store for digital typefaces
and a trading place for surrounding attitudes and ideas.

📄 about lineto.msg
📁 type department
📁 project departement

📁 stephan mueller
📁 masahiko nakamura
📁 nico schweizer
📁 martha stutteregger

📁 type department

up to higher level directory

[home|fonts by designers|fontindex|order]
[text fonts|headline fonts|graphic fonts|modular fonts|historic fonts]
[applications]
[next font]

up to higher level directory

▊ Eric Rodenbeck
umwow

This looks like browsing through someone's naked web directory, without any design at all. It would be trite if it wasn't curiously appropriate to the subject matter: fonts that look like 'other things' – pez, lego, dot-matrix printers, liquid crystal displays, etc. It's like they're saying, look, have a set of cultural associations with this design. Usually this is what designers think about, that there's going to be a set of cultural relations to their work and that their choices of typefaces, colors, compositions, etc. are going to make people think about certain things that they are orchestrating. Lineto pretty much admits this in their typography and in their web design as well, and tries neither to hide it nor to fetishize it – it's presented simply as how things are.

DEAD TYPE

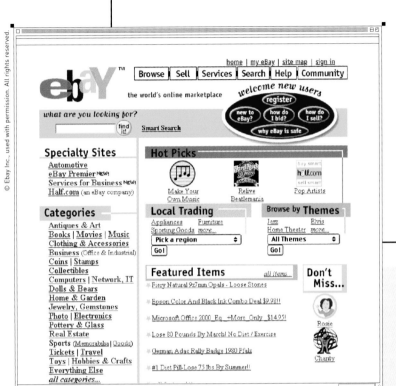

▌ EBAY

After Amazon, eBay is the other dominant ecommerce site on the web, but what sets it apart is that it is hard to imagine the basic eBay concept working anywhere else. Whereas Amazon is, at heart, a massive mail order catalogue, eBay's 'trading community' is reliant on, and makes use of, the unique properties of the web. In terms of design, eBay, like Amazon, adheres to the de facto web standards of content listed down the lefthand side, hypertext links underlined in blue and so on. Sheer weight of content make for a visually cluttered interface, but it is phenomenally successful. How much more successful could it be if it were laid out in a clearer, more coherent manner? That is the case that designers must make.

Sandy Speicher
MetaDesign, North America

I've always had this thing about cardboard boxes. Every time I get one, I can hardly bear to throw them out. I mean, usually they're totally reusable, and lots of people need boxes to mail things or to pack things or move things. They pay good money to buy boxes when I've got a bunch I can't seem to throw away. It's not that I'm a pack rat or anything, it just seems so obvious that someone might need the box I'm about to throw away.

And then came eBay. eBay, to me, exemplifies the value of the internet. Really, I haven't found anything yet that seems more innovative. It goes beyond providing a more efficient way to do a service you already do (pay bills, buy books, read the news); it actually 'facilitates the allocation of resources'. It, metaphorically, puts cardboard boxes in the hands of people that are looking for cardboard boxes.

I use eBay daily, often more than once a day. OK, often more than five times a day. I go whenever I'm bored to see if there are new Mona Lisa items there, to continue to build my collection. I've found some of the best Mona Lisa things on eBay: a Mona Lisa rubber duck, countless prints and advertisements, a Mona Lisa rug (yes, a rug!), and tonight I just paid for the Mona Lisa pin where she's holding a bag of Frito-Lay Potato Chips. Now where else could I find that??? (!!!)

I've got my system down. I have the Mona Lisa search bookmarked to sort by the new listings. If I see something I want, I add it to my 'watch list' and then I wait until the last day to bid. I've been burned before by people bidding too much too early. It can get competitive, you know.

There's something slightly exciting about an auction, much more interesting than a straight sale. It's the bit of strategy you develop, the non-zero sum game theory in bidding. I've got my bidding strategies down: I always bid five cents higher than even because most people bid evenly, I wait until at least the last day, and if I really want the item, I try to watch up to the last hour. I'll even jump in in the last three seconds if it's really important. I watch completed auctions to see what people bid to know what they might bid next time.

In fact, there are a few people that often outbid me. I've been watching them for over a year now. One day I got an email from one of the competitors. He'd been watching me too, and figured I was a collector just like him. So he decided to form a club that includes him (from Spain), a woman from England, a guy from Michigan and me. The Mona Lisa Social Club. And he's organizing an exhibition in Spain for us to feature our collections of Mona paraphernalia – eBay-collected paraphernalia. He's purchased over 350 items over eBay. And formed friends.

Now, I'm not the only one obsessed, my dad is pretty obsessed too. He sells used cameras; he used to have a pretty successful business at camera shows and through classified ads in camera magazines. Now he and all his friends are selling and buying through eBay. It's brought business back. My dad's got the complete selling and buying psychology down. He'll spend countless hours discussing it with me too.

STRIDE-ON

We love the boxes-within-boxes Flash interface of this site for Stride sports shoes. It is a very satisfying way of tackling a basic task – displaying the client's stock online. The various shoe models are viewed by selecting a box which then slides out of its stack and unfolds to reveal the chosen footwear. To add to the user experience, there are various Flash games and a downloadable screensaver. For those who prefer a more no-nonsense approach, a non-Flash version is available.

Sonia Harris

Soyabean Design

Its use of simple, vector-based illustrations allows for smooth animation while describing perfectly the shoe-box analogy, and showcasing the hi-res product shots elegantly, if a little sparsely. Uses the illusion of three-dimensions to great effect.

THIS IS REAL ART

There are several sites selling art over the web: this is one of the most elegant. A simple grid interface displays works for sale: click on an image to reveal more detailed information. Artist biographies are also available and there are links to other sites featuring that person's work. The ordering process is simple and logical. The whole experience is entirely in keeping with the product for sale – prints of images by cutting-edge graphic designers and illustrators. Ecommerce can be beautiful.

Currently showing 9 pieces

Josh Singer
Atomtan

I guess what I like about it is that it is simple, visually neutral (accentuating the vibrant work) and easy to navigate. I can get in and see the work quickly all in one navigation field, and navigate further to find a greater detail of information (artist info, materials/medium, price) and, finally, (my favourite part) to the 'view scale' window where I can see the work in scale with a human figure; a nice way to give the potential buyer an idea of how it will look in a room.

thisisrealart

Bless The Artist
Man With Rectangle

Screenprint
Printed on 150gsm paper
Size (hxw): 1188mm x 840mm
Edition of 100
1 of a series
Printed by Artomatic

Price: £175 (exc VAT)

Bless The Artist
Man With Rectangle

Screenprint
Printed on 150gsm pap
Size (hxw): 1188mm x 8
Edition of 100

Priscilla Duty
Siegel Gale

Stone's online catalogue is as functional and has as many photos as the printed books. The layout is easy to use, well designed but nothing flashy. It is form and function, simple and easy. You are dealing with photos, which already slows the web down a bit, so it is nice that there are no other distractions. They have started promoting more of their own product on the initial page so you can see what is new. The photos that they sell are in general more appealing than most stock houses.

You searched for: **Keyw**

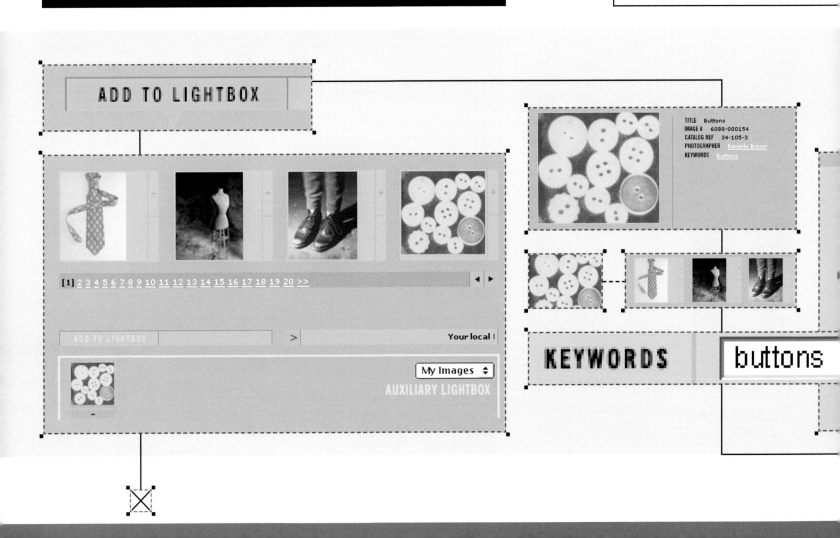

BUY

WWW.PHOTONICA.COM

design

DAVID NEILSON, ROHAN TAKHAR,
JOEY NEAL AND JOHN DUFFY

function

PHOTO LIBRARY

technology

JAVASCRIPT, HTML,
PROPRIETARY
BACK-END

111

STONE AND PHOTONICA

Photo libraries have been investing heavily in the internet in
recent years as they recognize the great advantages that online
selling offers them: no more expensive catalogues as thousands
of pages worth of images can be displayed online; fewer trans-
parencies to reproduce as many customers now prefer to
download digital files; smaller courier bills for the same reason;
fewer researchers to pay as web search engines become more
sophisticated. Both Stone and Photonica claim to represent the
top end of the market, a position reflected in the sophistication
of their site design. Both make great use of lightboxes – a means
for users to select and save images on the site and return to
them at a later date. Searching methods, as might be expected,
are very sophisticated with both sites offering a wide variety
of methods including keywords, photographer, image number,
subject matter, and so on.

Bil Bungay
TBWA, London

I'm an art director, I love images, I use images.
Photonica does images and needs me and other
mes to casually wander around their website
picking up their 'much better than stock shots'
stock shots. And how better to deliver their
wares than by serving them to me on the wwweb?
So let's say I need a picture of some pancakes
for a brilliant idea I've had for a maple syrup pro-
duct; I type (you guessed it) 'pancake' into the
'quick search' box and voilà! Loads of pictures of
pancakes! Better than sex.

Some industries were meant for the web and this
is one of them – the page layouts and navigation
systems have the right balance between function
and design and show a lot of understanding of
the image selection process. You can create your
own lightboxes on to which you can save any
images you have found en route and can review,
edit, mix and match them to your heart's content.
And what is absolutely fab is that not only does
Photonica.com automatically recognize you when
you return, just like the landlord at your local, but
your lightboxes are still there exactly as you
left them! Very nifty.

SKIM

Skim is a curious hybrid of etailer, community site and magazine. It is based on the idea of branding all its products with a unique serial number. This number, when followed by @skim.com, can be used as an email address linking together all Skim's customers. The website has three main components: a shop selling skim.com fashion and other selected products; a communication centre where users can set up their free email account and send free text messages; and Webend, an ezine area with games, stories, links, and so on. Offline, Skim has a shop in Davos, Switzerland and produces *Print*, a magazine.

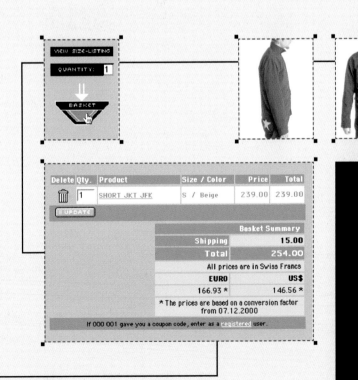

Thomas Petersen
MetaDesign, North America

Skim is designed with a beautifully balanced combination of the four parameters I feel essential for a great website: a unique concept, considered content, rounded aesthetics and functionality that makes it all work. I log out feeling I am the coolest shopper in the world.

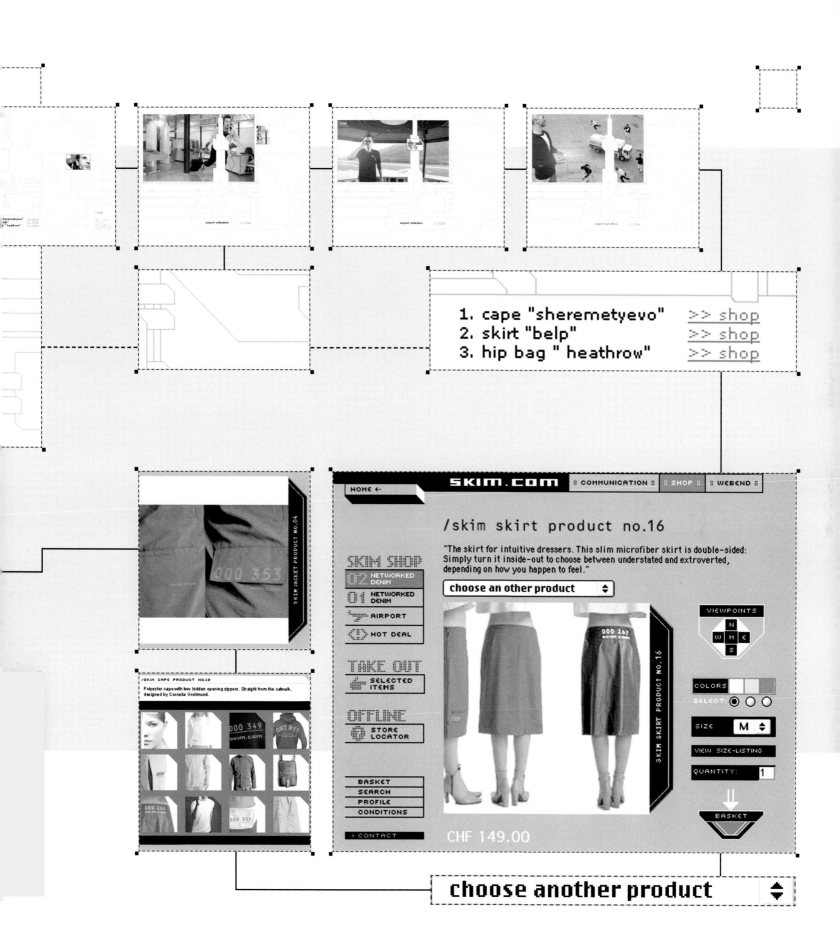

1. cape "sheremetyevo" >> shop
2. skirt "belp" >> shop
3. hip bag " heathrow" >> shop

SKIM.COM :: COMMUNICATION :: :: SHOP :: :: WEBEND ::

HOME ←

/skim skirt product no.16

"The skirt for intuitive dressers. This slim microfiber skirt is double-sided:
Simply turn it inside-out to choose between understated and extroverted,
depending on how you happen to feel."

choose an other product

SKIM SHOP
02 NETWORKED DENIM
01 NETWORKED DENIM
✈ AIRPORT
HOT DEAL

TAKE OUT
SELECTED ITEMS

OFFLINE
STORE LOCATOR

BASKET
SEARCH
PROFILE
CONDITIONS

→ CONTACT

CHF 149.00

VIEWPOINTS

COLORS
SELECT:
SIZE M
VIEW SIZE-LISTING
QUANTITY: 1
BASKET

/SKIM CAPE PRODUCT NO.18
Polyester cape with two hidden opening zippers. Straight from the catwalk,
designed by Cornelia Grolimund.

000 349
skim.com
007 917
000 267
skim.com
000 353

choose another product

LISTEN

Record companies have realized that, rather than a threat, the web is a great marketing tool for bands, being highly suited to the 'fanzine' aesthetic and a natural fit with young, computer-literate audiences. Add to that sites which offer mixing facilities, the radio and music-related TV sites and the web is almost as rich an aural experience as it is visual.

GORILLAZ

Gorillaz is a pop group devised by Jamie Hewlett, the creator of the Tank Girl comic strip, and Brit band Blur's Damon Albarn. The Gorillaz site is set in their record company Kong Studios where users can explore and get background on the band's (cartoon) characters. The site is highly interactive with lots of fun and games. If you can't be bothered to explore, each interactive game can be accessed directly via a scrolling menu.

Mike Maxwell
Digital Arts

This is a well produced site with high production values, lots of innovative details and of course the sublime visual direction of Jamie Hewlett. I felt the inter-action was slightly confusing and hampered by speed issues, but the overall energy with which the site is put together raises it beyond the normal 'click-reaction' experience. The interactive computer inter-faces are great.

AMON TOBIN

Created by Hi-Res!, Amon Tobin's website promotes both him and his album Supermodified. The site's look and feel is of sampled data, imagery and sound; it reflects both the way in which Tobin finds inspiration and the way he makes music. As well as being an innovative way to find out more about Tobin, the site also has a great sound toy, the Supermodifier V1.0, an online sequencer that gives the user four sets of loops to interact with via the keyboard.

■ FUNKSTORUNG

German techno makers Funkstorung had their site designed in part by The Designers Republic, which explains the distinctive look. The site's content is comprehensive and errs on the quirky side, including a feature that tells users how to pronounce the band's name. MP3 sound samples play instantly through the Flash interface, without the need to open up a player.

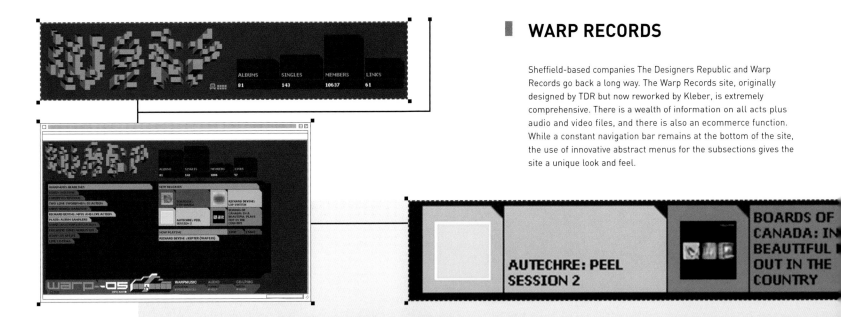

WARP RECORDS

Sheffield-based companies The Designers Republic and Warp Records go back a long way. The Warp Records site, originally designed by TDR but now reworked by Kleber, is extremely comprehensive. There is a wealth of information on all acts plus audio and video files, and there is also an ecommerce function. While a constant navigation bar remains at the bottom of the site, the use of innovative abstract menus for the subsections gives the site a unique look and feel.

James Tindall
squarerootof-1.com

Although the new Warp site was not launched until January 2001, the design, the concept and much of the client side build was actually produced during the summer of 1999. It was late September that year when I first saw the site and I was shocked, it was quite unlike anything I'd seen before. If it had actually gone live at that time, I think it would have shocked a lot of other people too. As it was, due to one thing and another, 15 months went by before it was finally launched, but thanks to the quality of the design and the outstanding implementation it still looks very fresh.

The complex geometry and 3D protrusions of the Warp site mark the transition from 'information design' to 'information architecture', and this is modern architecture. Like the buildings of Richard Rogers, there is no facade hiding the true nature and purpose of the construction. Such transparency is only possible when a great understanding of inner workings is combined with a great understanding of structures and surfaces. Unlike the fake transparency of the iMac with its wholly

uninformative but seductive view of naked circuitry, the transparency of the Warp interfaces presents the user with the reality of the dynamic and growing information structures inside the Warp data bases. Like an information machine whose cogs and wheels have been given a lick of paint and then left open to the tinkering of the user, a mouseover here and a click there and the Autechre soundtrack of its inner workings can be heard as it re-sorts the back catalogue by title, extracts the relevant news items or grows a new tree of video or radio clips.

There is nothing decorative here, no empty signifiers, just pure content, pure function, pure data presented as beautiful form. The navigation goes from conventional tabs to unusual protruding shapes but remains remarkably transparent to even the first-time user. It is sometimes difficult to know whether you've seen everything, but if you want to do something specific – find information on a particular artist, check the forum, or buy the latest album – it's quick and it's simple.

For such a cult record label perhaps more of the content could be provided by the users them-selves. There were plans to allow registered users to submit reviews for each release but as it is the beautifully implemented forum and the new chat room keep the Warp anoraks happily swapping bleeps.

One of the first things that struck me was how well the designers had chosen the artist colours. Colour coding does not always work, and often feels too arbitrary, but here it works incredibly well. I suspect that anyone who is at all familiar with Warp artists could successfully guess most of the artist-colour associations. It is this synesthetic bonding of colour and sound, geometry and data, graphic design and music, that makes the Warp site work.

Danny Brown
Mr Noodlebox

This is an impressive example of a contemporary offline brand being taken online very successfully. My only slight quibble would be that the Designers-Republic style is very often imitated on the web, which has to a degree devalued its charm. But then again, bearing in mind that The Designers Republic worked on the original version of this site, now updated by Kleber, you can't tar them with that one!

I think it integrates the various strands of the record label very well – the site comes across as one consistent whole, rather than a news section linked to a radio site linked to a gallery linked to a shop. The sub-branding of the individual bands fits in wonderfully.

Its interactivity means it's very engaging – using the site is kind of like imagining you're living in the future on a space ship or something. The chatrooms further expand on this – they are wonderful new ways of seeing people chat and communicate visually.

I can buy all the Warp records which otherwise are generally hard to locate, plus I can find out what they sound like – Warp is a small label that doesn't get major airplay, so the site has to serve as a broadcast channel, which it does via the Radio/Video sections. I use it at work and home – I remember dialling up to find out where a Warp party was once, and sure enough there was a map on the site. Just as well as it was in the middle of nowhere.

SPEEDY J

The warping image at the front of the site signals the mind-bending sounds that Rotterdam DJ Speedy J is capable of creating. The stark industrial feel of the site, coupled with abstract navigation, complements his mind-warping music. There are web-exclusive tracks and videos – but this site is only really recommended for die-hard fans.

Andy Slopsema
umwow

I originally went to the Speedy J site for information about any upcoming live performances, or notices of new releases. I was quickly thrust into an environment that felt more like a space than a set of pages. Whenever I come back, I feel like I'm remixing the experience itself.

I find it both exhilarating and frustrating at the same time. It was harder than I would have liked to find the information I was looking for, but in the process of searching every nook and cranny I became fascinated with trying different approaches, experimenting and seeing what would happen. I really don't have any idea what's going on behind the scenes so to speak. I know that there are starting points which provide a loose framework for 'navigating', but it feels like I have to make choices about what's going to happen. This can be disconcerting or exciting.

LEFTFIELD

The Leftfield website is fairly standard fodder. However, their free
toy – the Swords Remixer – which allows users the opportunity to
remix three of the band's tracks, is one of the best on the web.
Users interact with the tune using both keyboard and mouse; there
is an added bonus of great audio quality, which is often lacking
in this kind of technology.

Bil Bungay
TBWA, London

Contemporary design in a Leftfield style with lots of 'easy to use – not so easy to read' graphics that allow you to access the inevitable photo library, music tracks, interviews, gig lists, games and the best bit: a cool-looking and sounding mixing desk that could quite easily eat up an evening or two.The only problem I really have with the site is that it exists. By that I mean that until visiting this dot com, Leftfield had possessed for me a level of cool only the likes of Keith Moon/Richards or Jim Morrison/Hendrix have possessed. But after seeing the pictures of 'the band', having listened to an embarrassing interview (in that annoyingly weenie Real Player format), I have to say that I was disappointed and my enthusiasm for them waned.

128 LISTEN

WWW.MTV2.CO.UK

design
DIGIT

function
PROMOTIONAL

technology
FLASH

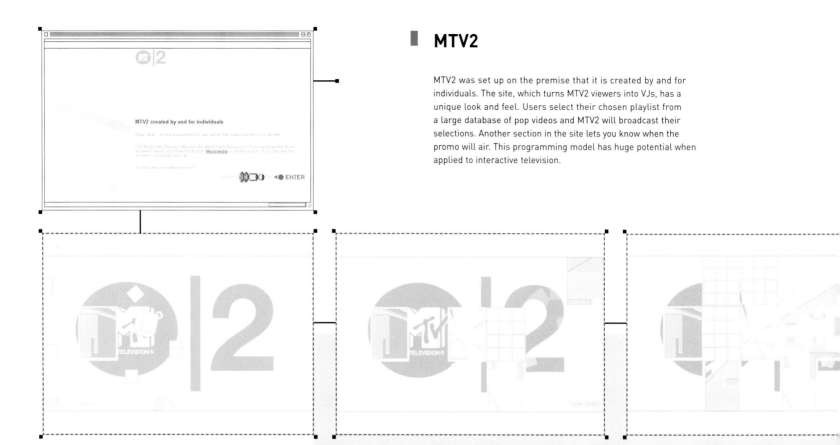

MTV2

MTV2 was set up on the premise that it is created by and for individuals. The site, which turns MTV2 viewers into VJs, has a unique look and feel. Users select their chosen playlist from a large database of pop videos and MTV2 will broadcast their selections. Another section in the site lets you know when the promo will air. This programming model has huge potential when applied to interactive television.

Damian Fagan
Lewis and Partners

MTV2 is a visually arresting and generally easy site to use and navigate through despite its initially confusing presentation. An unusual interface and the utilization of trendy hi-tech aesthetics provides the target audience with an attractive environment.

The opportunity to create the playlist for an hour of airable videos that would actually appear on MTV2 is intriguing. However, the perceived likelihood of this actually occurring is similar to the perceived likelihood of winning the lottery – nil. I would not be inclined to return often based on this possibility.

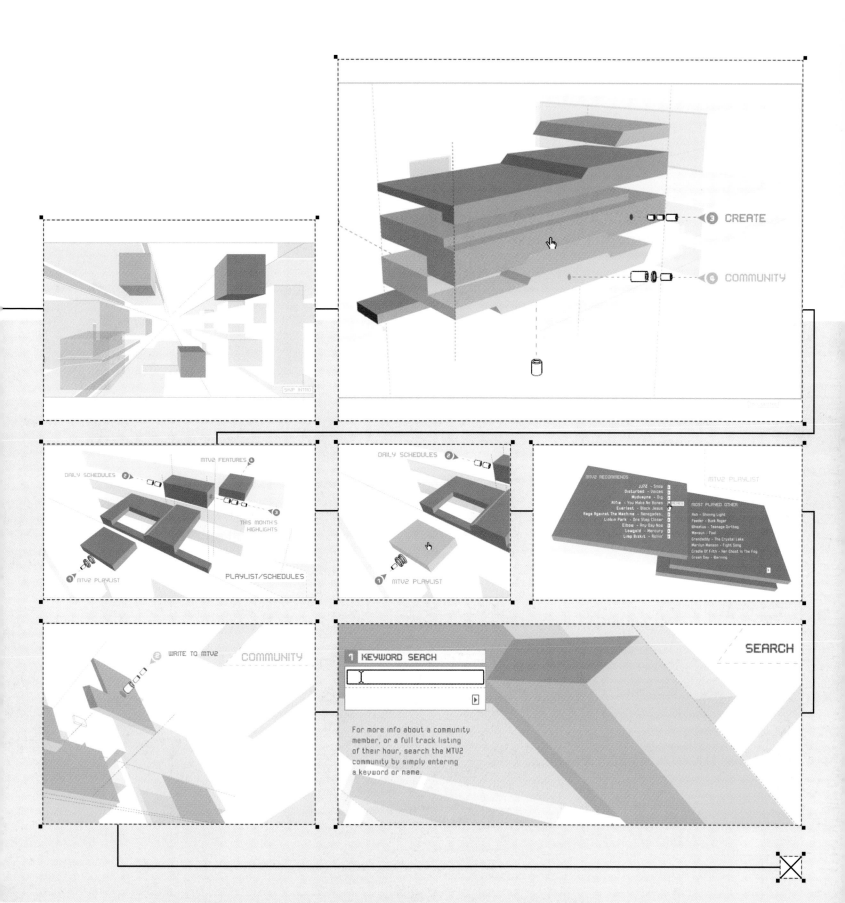

SKIP INTRO

③ CREATE

④ COMMUNITY

MTV2 FEATURES ④

DAILY SCHEDULES ②

DAILY SCHEDULES ②

THIS MONTH'S
HIGHLIGHTS

③

① MTV2 PLAYLIST

PLAYLIST/SCHEDULES

① MTV2 PLAYLIST

MTV2 RECOMMENDS

JJ72 - Snow
Disturbed - Voices
Mudvayne - Dig
Rifle - You Make No Bones
Everlast - Black Jesus
Rage Against The Machine - Renegades
Linkin Park - One Step Closer
Elbow - Any Day Now
Lowgold - Mercury
Limp Bizkit - Rollin'

MTV2 PLAYLIST

MOST PLAYED OTHER

Ash - Shining Light
Feeder - Buck Roger
Wheatus - Teenage Dirtbag
Manson - Fuel
Grandaddy - The Crystal Lake
Marilyn Manson - Fight Song
Cradle Of Filth - Her Ghost In The Fog
Green Day - Warning

② WRITE TO MTV2 COMMUNITY

1 **KEYWORD SEACH**

▶

For more info about a community
member, or a full track listing
of their hour, search the MTV2
community by simply entering
a keyword or name.

SEARCH

MANAGE

The web shows its serious side as an organizational tool: internet banking, share-dealing sites and corporate intranets all exhibit the web's suitability for helping us organize and administer. This field, however, is where non web-based digital media really come into their own. Palm-held devices are increasingly popular and increasingly sophisticated. Add a mobile phone and a laptop and the portable office is a reality. But what our respondents are really waiting for is a single device which combines the advantages of all three in a lightweight, durable, platform-independent package that will still work after having been dropped from a great height.

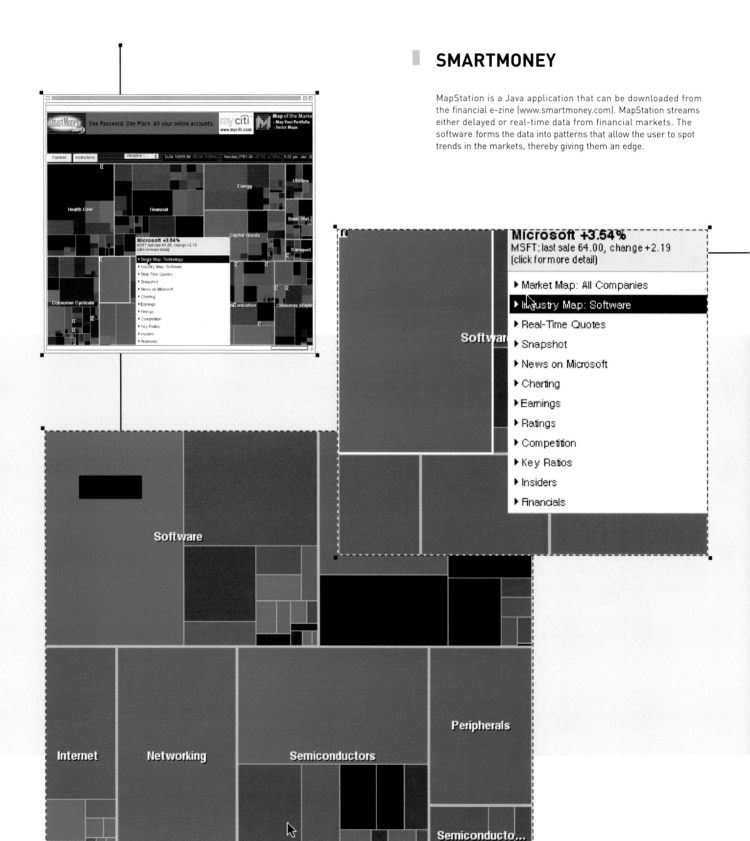

SMARTMONEY

MapStation is a Java application that can be downloaded from the financial e-zine (www.smartmoney.com). MapStation streams either delayed or real-time data from financial markets. The software forms the data into patterns that allow the user to spot trends in the markets, thereby giving them an edge.

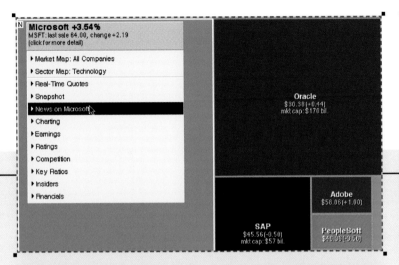

Microsoft +3.54%
MSFT: last sale 64.00, change +2.19
(click for more detail)

▸ Market Map: All Companies
▸ Sector Map: Technology
▸ Real-Time Quotes
▸ Snapshot
▸ News on Microsoft
▸ Charting
▸ Earnings
▸ Ratings
▸ Competition
▸ Key Ratios
▸ Insiders
▸ Financials

Oracle
$30.38 (+0.44)
mkt cap: $170 bil.

Adobe
$58.06 (+1.00)

SAP
$45.56 (-0.50)
mkt cap: $57 bil.

PeopleSoft
$46.36 (-3.50)

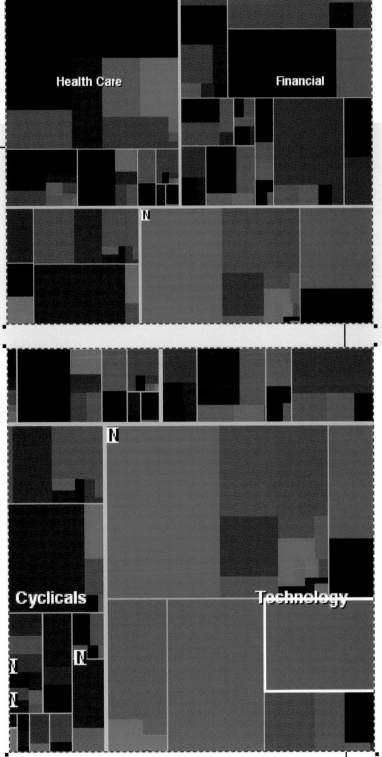

Health Care

Financial

Cyclicals

Technology

Cesar de Castro
agency.com

Smartmoney.com has real, dynamic, useful information married to deep interactivity which makes the user experience truly immersive. It's easy to use, technically reliable, has customized information and is smartly laid out. Other financial sites don't have the level of interactivity that this site presents with its Java programming – you can rollover charts and get deeper information that's customized to your needs. What makes it 'beautiful'? The Java applets which are solid and useful; the 'market map' is very cool and very useful. I use it for one to two hours, both at home and work.

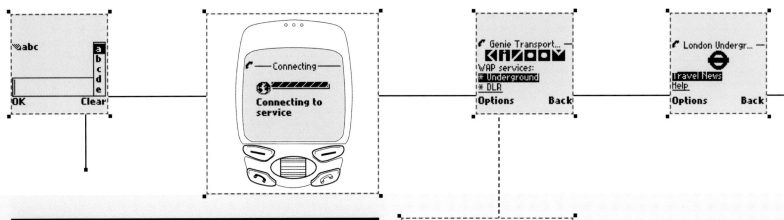

Michael Schmidt
k10k

on the Palm Pilot
It's small, sturdy and handy to carry
around: it manages to be small
enough to fit in a pocket, yet large
enough to be useable. Everything
has been designed to fit well together
– there's no wasted space, no
bloated feature set. It merges with
the laptop for that full-on calendar
experience, and allows you to get
news (through the AvantGo system)
on the road. It's extremely handy on
boring train rides. I use it at home,
at work, on the tube, in planes, trains
and automobiles. My favourite part
is the infrared connection, so you
don't need all those pesky cables –
but it has ugly 1980s graphics, it
does not do video, audio or games,
and you cannot yet use it as a phone.

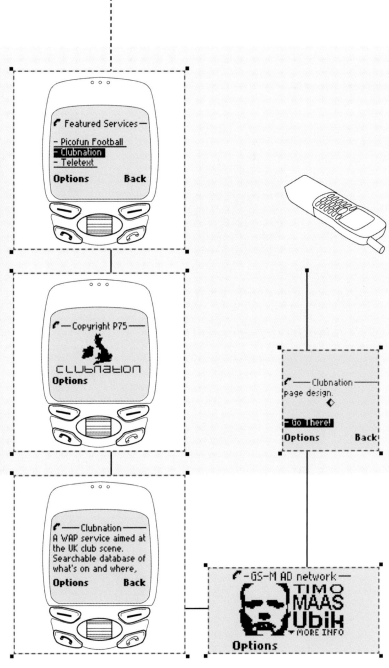

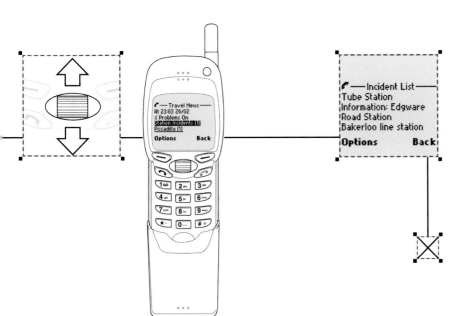

PERSONAL DIGITAL ASSISTANT

PDAs or palm devices have become hugely popular, something few would have predicted with certainty after the demise of Apple's Newton device. PDAs provide a glimpse into what many believe will be the future for the internet: relatively cheap, portable devices which combine access to the web with organizational and communication functions. The next step is to add a mobile phone and more powerful computing with perhaps video and audio playback to create a truly portable universal communications device that allows the user to carry out any of the activities identified in this book, wherever they may be.

Erik van Blokland
LettError

on the Palm Pilot and Nokia phone

It's small and simple. It doesn't try to be a palm-sized PC, it's a different thing, with different needs. It works very well. Mine ain't pretty, but I appreciate the fact that almost every aspect of it proved useful, and that doesn't happen very often with appliances, unfortunately. It talks to my tiny Nokia with infrared so I didn't have to buy a new organizer and a new phone. Furthermore, the screen of the phone can be small because it's not pretending to be a web browser. My favourite part? Most software for it is excellent and free. Least favourite thing? The screen cracks when dropped.

Jonathan Wells
ResFest

on Handspring Visor

It can store all my data and run numerous add-on programs downloaded from the net. It's small, easy to use and has a big screen. The two coolest features are its ability to infra-red beam numbers back and forth from my mobile phone, and the program Vindigo, the killer app of PDAs, which synchs new info for cities all over the world including movie show-times, restaurants, shops and more – and lets you know where they are from your exact(!) location. I use it for one to five minutes but find myself forget-ting to log in meetings, and then missing them. I synch it at the office, but it comes in handy most while travelling. I love the simple OS, thank god it's not Windows. The worse thing about it is that it is yet another device. I'm waiting for the successful merging of the mobile phone, music/media player and PDA.

MANAGE
design
function
technology

137

WWW.VINDIGO.COM
VINDIGO
CITY GUIDES
PALM OS

Alex Wittholz
Helios

I have yet to find an interactive networked device that really lives up to the hype. Palms, phones, pagers or email pagers are useless until they can all be rolled into one device. DoCoMo's i-mode phones are semi-promising. Printers, cameras, DVD decks, firewire drives, etc. are really too simple to be considered interactive. One extremely interesting, though not interactive, device is the DVD burner included with the new Apple G4s. That will change everything.

Geert Lovink

This is not the time to ask people about their personal taste or favourite sites. We arrived in the age of the internet economy long ago and it is now going through its first recession. The web has become a world of lawyers and consultants. The overall function of web design has rapidly mutated; it is no longer to create demo design for the web as a whole, if that mythological time ever really existed. The reality of the web today is shown in the list below.

In a web top 100 compiled according to the number of hits, taken from http://www.100hot.com/directory/100hot/index.html, the first 20 are all large corporate and financial sites, search engines and ecommerce.

1 – yahoo.com	11 – cnet.com
2 – microsoft.com	12 – fortunecity.com
3 – lycos.com	13 – chek.com
4 – aol.com	14 – looksmart.com
5 – altavista.com	15 – ugo.com
6 – egroups.com	16 – amazon.com
7 – excite.com	17 – snowball.com
8 – go.com	18 – usa.net
9 – google.com	19 – brinkster.com
10 – cnn.com	20 – quote.com

Innovative and creative web design has lost its hegemony over the overall look of the web; it is therefore time to rethink and redefine its position. Either it declares all-out war on mainstream American technology and news portals, which is unlikely, or it becomes truly obscure and develops its own parallel universe of beauty. More feasible is the creation of an exclusive global design class (similar to the ones in fashion, architecture and the art market): a professional high/ hype culture class of experts, feeding into the education system and the niche market of web design magazines. This process is already well under way.

There are many who feel unease about this tendency towards glamorous aloofness. We could take the initiative and question the current trend towards cosy uselessness. Web designers could reclaim the internet, for example, through a critical engagement in open-source software, peer-to-peer architecture and early design involvement in the development of mobile phones, set-top boxes, hand-held com-puters and other appliances. There is a growing need to break through the impasse that we face at the moment, where sophisticated web design still pretends to be avant-garde but has in fact lost its grip on web reality. Conceptual web design is in danger of becoming marginalized; or it may marginalize itself if it does not develop a critical understanding of the rapidly changing economic environment it is working in. Window dressing in a social and cultural vacuum – the inherent problem of all design – has always been around, and it always will be. It is not that web design has decayed or been betrayed: quite the opposite. Flash technologies have created a second wave of innovation, a renaissance after the first HTML wave of the mid-nineties. What is frightening is the somewhat unconscious isolation of the web. The New Economy is increasingly defined by fluctuations in the stock markets, it is no longer driven by the will to pursue technological innovation. It is ignorant of Flash applications, streaming media or 3D virtual environments, to name just a few examples.

The 'usability' discourse is experiencing a similar slow regression. Research into the 'stickiness' of sites, measuring the user-friendliness of a site's design and the frequency of visits, once served the rapidly growing user base, but navigation has become a non-issue thanks to usability efforts. Now usability research has turned against itself, advising companies how best to fit into the mainstream mono-culture.

Within the internet departments of companies the pressure to generate cash is gigantic. The argument that profile can be raised with funky design experiments is no longer convincing. The attention economy is dead. 'Aggregating "eyeballs" is not, in and of itself, a business model', Fortune magazine concluded recently. Attention may contribute to branding but it has failed to generate the required revenues.

I would therefore make a strong argument for web design to disassociate itself from usability theory which, despite all the good intentions of researchers such as Jakob Nielsen, Brenda Laurel and others, has had the effect of streamlining the web. It is time to uncover other unlikely futures for web design through new alliances. If usability advocates would understand that its partners in crime are designers, not the managers and CEOs, then the real work could start. At the moment usability is becoming complicit with the infotainment capital, pretending to do good work in the name of the 'average user'. Many people do not buy that story any more. It is time to start making a distinction between the (do good) goals and work of the movement that Nielsen is speaking on behalf of and its objective workings inside the industry. Nielsen is a great critic. Perhaps it is time to position his work in a larger context and reflect on its workings. Usability is part of the game. Its advocates are not innocent outsiders but powerful corporate consultants. It is time to include this fact and refine what critical internet research could be.

Geert Lovink is a Dutch media theorist and net critic based in Canberra, Australia. He is co-moderator of the www.nettime.org mailing lists and organizer of conferences and temporary media labs. He is the author of Uncanny Networks, a collection of interviews with media theorists and artists (Pluto Press Australia, 2001). His current topics include a critique of the New Economy, software as culture and strategies for net activism.

WATCH

Heavy – 022
www.heavy.com
Designed by: Heavy.com
Technology: Flash, Windows Media
Player, Quicktime, Real Player

Atom Films – 024
www.atomfilms.com
Designed by: Atom Films
Technology: Real Player, Windows
Media Player, Quicktime, Flash

Banja – 026
www.banja.com
Designed by: Chman Online
Technology: Flash

Center of the World – 028
www.center-of-the-world.com
Designed by: Hi-Res!
Commissioned by: LeAnne Gayner
at Artisan Entertainment
Technology: Flash

Nosepilot – 030
www.nosepilot.com
Designed by: Al Sacui
Technology: Flash

RESEARCH

Google – 034
www.google.com
Concept: Larry Page
and Sergey Brin
Design and programming:
Google, Inc.
Technology: HTML, JavaScript

Altavista Image Search – 035
www.altavista.com/
cgi-bin/query?pg=q&stype=simage
Credits: AltaVista team
Technology: Proprietary

k10k – 036
www.k10k.com
Credits: The KALIBER10000
crew: mschmidt + token + per: the
semi-bald posse with a touch of
John Lennon and a slight whiff of
wet dog lingering in the air.
speak@k10k.net
Technology: Photoshop,
Imageready, Illustrator, Golive.
Software platform for the site:
custom-built ASP back-end and
administration system running on
a Windows NT server. A mixture of
HTML, DHTML and homegrown JS.

Skyscraper – 040
skyscraper.paregos.com
Designed by: Paregos
Technology: Flash

Bits and Pieces – 042
www.noodlebox.com/bitsandpieces
Designed by: Danny Brown
Technology: Macromedia
Director Shockwave

Triplecode – 046
www.triplecode.com/projects/
nile/index.html
Designed by: Triplecode
Technology: Macromedia Director
Shockwave, JavaScript, Windows
Media Player (audio playback).
XML and MQL – MoodLogic's
Music Query Language
www.noodlebox.com/bitsandpieces

Typographic 56 – 047
www.typographic56.co.uk
Credits: Typographic 56 for
Typographic, the journal of the
International Society of
Typographic Designers
Design direction: Nicky Gibson
Web development: Matthew Knight
Discussion on typography by:
Nicky Gibson,
Mike Reid, Richard Ho
Typographic experiments:
Deepend team (individual credits
on the website)
Technology: Flash

PrayStation – 048
www.praystation.com
Designed by: Joshua Davis
Technology: Flash

PLAY

Nickelodeon – 052
www.nick.com
Designed by: Nickelodeon Online,
a division of Viacom International,
Inc.
Technology: Flash, Shockwave.
Featured snowboarding game:
Macromedia Director

Nerd Olympics – 053
www.nerdolympics.com
Credits: Starlet, eBoy,
Aeroman, Icon Gamelab
Technology: Macromedia
Director Shockwave

Netbabyworld – 054
www.netbabyworld.com
Credits: Net Baby is part of the
Swedish ACNE Family
Technology: Macromedia
Director Shockwave,
DHTML, JavaScript

Sodaplay – 056
www.sodaplay.com
Designed by: Soda
Technology: JavaScript

Modifyme – 058
www.modifyme.com
Sound/Design/Code:
James Tindall
Technology: Flash

Safeplaces – 060
www.safeplaces.com
Credits: G.COM
Technology: Flash, Quicktime

SHARE

Napster – 064
www.napster.com
Credits: Shawn Fanning
Technology: Napster server
and client application

Stickernation – 066
www.stickernation.net
Credits: tak!TAK!
Technology: Flash

White noise central – 068
www.whitenoisecentral.com
Design: 3 Form
Technology: Flash, PHP

CHAT

Dreamless – 072
www.dreamless.org
Created by: Joshua Davis
Technology: JavaScript, UBB

Metafilter – 073
www.metafilter.com
Credits: Designed and
programmed by Matthew Haughey,
with some SQL assistance from
Jeff Pierzchalski and Eric Costello
Technology: Custom scripts
database interface, HTML, CSS,
Allaire's ColdFusion, MySQL,
IIS 5.0 on Windows2000
advanced server

Playdo – 074
www.playdo.com
Created by: Andreas Rehnberg
Technology: WindowsNT-based
webserver using Microsoft SQL-
server 7. Interactivity (3D city,
game, online-editor): Macromedia
Director 7 and 8. Graphic design:
Adobe Photoshop 5 and Illustrator
8. HTML, JavaScript, ASP and SQL-
scripting: Notepad. Database
design: Microsoft Visual Studio 6

Habbo Hotel – 076
www.habbohotel.com
Development house: Sulake Labs,
www.sulake.com
Client: Habbo Ltd/Dee Edwards
Original concept: Aapo Kyrölä,
Sampo Karjalainen
Graphic designers: Sampo
Karjalainen, Ilkka Kallasmaa,
Tuukka Savolainen, Jyrki Myllylä,
Tommi Musturi, Mikko Väyrynen
Server-side Java programming:
Aapo Kyrölä

Client-side Director Lingo
Programming: Otto Nieminen,
Aapo Kyrölä
Copy: Laura Smithson
Technology: Graphics:
Macromedia Director's Paint
window, Adobe Photoshop
Client side: Macromedia Director
Server side: Custom FUSE-server
technology (Java-based), SQL-
database, Unix

Sissyfight – 080
www.sissyfight.com
Executive producer: Marisa Bowe
Concept: The staff at Word
**Game design and project
management:** Eric Zimmerman
Lead programmer:
Ranjit Bhatnagar
Additional programming:
Wade Tinney
Art direction: Yoshi Sodeoka
Art and interface design:
Jason Mohr
**Producer and assistant
game designer:** Tomas Clark
Copy: Tomas Clark and
Daron Murphy
Sound and music: Lem Jay Ignacio
Communication engine:
Lucas Gonze
Additional project management:
Michelle Golden
Technology: Shockwave with
network Lingo

Cycosmos – 084
www.cycosmos.com
Designed by: Maurus Fraser,
Timo Arnall, Neil Gardiner,
I-D Media
Technology: Sun servers,
Apple WebObjects Application
Server, HTML, Objective-C,
JavaScript. Informix Database,
HTML and JavaScript

SMS Messaging – 085
Credit: Motorola, Inc.

LAUGH

flip flop flyin' – 088
www.flipflopflyin.com
Designed by: Craig Robinson
Technology: HTML and a hell of a
lot of little GIFs; Photoshop 5.5,
Imageready 2 and SimpleText

hot or not – 090
www.hotornot.com
Designed by: James Hong and Jim
Young
Technology: Linux Apache, MySQL
PHP

The Onion – 091
www.theonion.com
Designed by: The Onion staff
Technology: HTML

TRAVEL

Lufthansa – 094
www.lufthansa.com
Credits: Lufthansa eCommerce
Technology: HTML

Room12 – 095
www.room12.com
Created by: Scott Galloway, CEO,
Brand Farm
Site design and concept: Ellipsis
Site production: Addis
Creative director: Jonathan Taylor,
Brand Farm
Editor: Newell Turner
Technology: Runs on ATG Dynamo
4.51. The site uses the Dynamo
Application Server (DAS), the
Dynamo Personalization Server
(DPS) and the Dynamo Commerce
Server (DCS). Web servers:
Netscape/Sun iPLANET servers.
RDBMS: Oracle 8i

Mycity – 096
www.mycity.com.br
**Project coordination, curatorship
and design:** Jair de Souza
**Project and coordination of
technology:** Alexandre Ribenboim
Creation: Jair de Souza,
Suzana Apelbaum

Design assistant: Clara Martins,
Elisa Janowitzer
Sound: Paulo Vivacqua
Flash: Dani Lima, Luis Mattos,
Yuri Lott
Technology: Photoshop and
Illustrator (layout and static
images), Flash (multimedia:
animation, interactive and sound).
Homesite: HTML programming.
Database integration and ASP
pages programming: Visual
Interdev. Site server: IIS 4.
Database server: Microsoft SQL
server.

BUY

Buyarock – 102
www.buyarock.com
Founders: Walter Ife,
Harry Groome
Designer/illustrator/writer:
Rob Reed
Programmers: Noam Solomon,
Andrew Wint
Writers: Walter Ife, Darleen
Scherer
Producers: Harry Groome, Molly
Groome, Kym Overton, Darleen
Scherer
Web design: The Chopping Block
Back-end development: Aurora &
Quanta and SocketNET
Technology: Photoshop, Illustrator,
Flash, PHP, MySQL, JavaScript,
Generator

Amazon – 104
www.amazon.com
Credits: Amazon.com
Technology: In-house developed
software

Lineto – 105
www.lineto.com
Concept and design: Stephan
Mueller and Cornel Windlin
Technology: Dreamweaver,
Photoshop, ImageReady, BBedit,
Acrobat, SimpleText, Formel

eBay – 106
www.ebay.com
Credits: eBay, Inc.
Technology: In-house developed
software

Stride-On – 108
www.stride-on.com

Design directors: Nathan Usmar Lauder, David Rainbird
Programmers: Rob Cummins, Noise Crime, Brad Lowry
Design group: Fibre
Marketing executive: Craig Throne
Client: Overland Group
Technology: Shockwave Flash, HTML, Shockwave Director, served from Unix

This is Real Art – 109
www.thisisrealart.com

Design and programming: Intro
Creative direction:
Adrian Shaughnessy
Design: Nima Falatoori
Programming: Wilf Johnson
Production: Sue Rollings and Dominic Goldberg
Technology: Flash 3+, DHTML/JavaScript. Windows NT Server. ASP scripting. Ecommerce system developed in-house

Stone – 110
www.tonystone.com

Credits: Getty Images Design Studio
Technology: ASP, HTML. Search engine based on Fulcrum.

Photonica – 111
www.photonica.com

Credits: David Neilson, Rohan Takhar, Joey Neal, John Duffy
Technology: Oracle 8i RDBMS, Windows NT4 Server operating system, Apache web server, PHP, Proprietary, JavaScript, HTML

Skim – 112
www.skim.com

Head of Webfactory/Project management: Christian Vaterlaus
Content editor: Reto Vogler
Perl/HTML programmer:
Daniel Steiner
Art director: Franziska Eriksen
CTO, System architect:
Lukas Rüegg
PHP/MySQL: Phil Reichmuth
Graphics: Daniel Lüthi

Technology: PHP4, Flash, HTML, DHTML, PDF, RealMedia, Quicktime.
Operating system: Linux.
Webserver: Apache. Database: MySQL. Messageboard: DC Forum 2000. Mailcenter: Outblaze. SMS: own large account, own response tracker. Webshop: Intershop 4.0.
Payment system: WireCard

LISTEN

Gorillaz – 116
www.gorillaz.com

Designed by:
Get Frank and Zombie
Technology: Shockwave, Flash

Amon Tobin – 118
www.amontobin.com

Designed by: Hi-Res!, London
Commissioned by: Peter Quicke at Ninjatune
Original cover artwork: Openmind
Technology: Flash 4

Funkstorung – 119
www.funkstorung.com

Designed by: Leekon
Sounds and loops:
Michael Fakesch
Text edit:
PS 199 and Andrea Fischer
Photos: Tina Winkaus, Tobias Titz
Scans: Jeff Ingram
Sources by: PrayStation
Powered by: Frank Kirchner
Basic design: The Designers Republic
Technology: Flash

Warp Records – 120
www.warprecords.com

Designed by: The Designers Republic/Kleber Design
Technology: Brain-aided design, computers and Kleber

Speedy J – 124
www.speedyj.com

Designed by: Jan Willem van den Ban
Design company: Beng
Programmers: Ronald van der Feer, Carsten Schwesig (homepage/interactive face image)
Technology: Mainly Flash. Director for homepage/interactive face image only. All music is transferred over the www as streaming MPS Flash movies

Leftfield – 126
www.leftfield-online.com

Designed by: Kleber Design, James Tindall
Technology: Macromedia Director Shockwave, Flash

MTV2 – 128
www.mtv2.co.uk

Designed by: Digit
Technology: Flash4, Flash Generator, 3D Studio Max, Vector 3D, Freehand 8

MANAGE

Smartmoney – 132
www.smartmoney.com/mapstation

Credits: smartmoney.com
Technology: JavaScript

Personal Digital Assistants – 134
Hardware: Palm, Inc. Nokia Telecommunications, Handspring
Software: Palm Operating System: Palm Inc.,
Vindigo by Vindigo, Genie Wap system by British Telecom Cellnet

We have endeavoured to provide full and accurate credits for all sites featured. If there are any mistakes or omissions please contact us via Laurence King Publishing and we will correct them in future editions.
The authors